LIBRE LIBRE!

SIGNAL:04

SIGNAL:04

Signal:04 edited by Alec Dunn & Josh MacPhee
© 2015 PM Press
Individual copyright retained by the respective
writers, artists, and designers.

ISBN: 978-1-62963-106-6
LCCN: 2015930876

PM Press, PO Box 23912, Oakland, CA 94623
www.pmpress.org
www.s1gnal.org

Design: Alec Dunn & Josh MacPhee/
AntumbraDesign.org

Cover photograph: One of two Peace Navy boats
supporting an ILWU picket of the *Nedlloyd Kembla*,
a Dutch freighter carrying South African cargo
(photo by Mary Golden). Frontispiece: outside
photo from Juárez, Mexico, 2012; inset graphic by
Kamel al-Mughanni from *Palestinian Affairs* issue
215–216, 1991. Background image on this spread
is a photograph of Shannon Muegge printing at
Punchclock in Toronto. Image on following page
spread from *Palestinian Affairs* issue 15, 1972. Back
cover main image adapted from Shafiq Radwan's
cover for *Palestinian Affairs* issue 115, 1981.

Printed in the United States.

Thanks to everyone who worked on this issue, and
as always, their patience with the tardiness of the
editors. Special thanks to the Palestine Poster Project,
Book Thug Nation, Aaron Elliot for lending some
Three Continents Press books, and everyone at PM
Press for their continuing support of this project.

SIGNAL
is an idea in motion.

The production of art and culture does not happen in a vacuum; it is not a neutral process. We don't ask the question of whether art should be instrumentalized toward political goals; the economic and social conditions we exist under attempt to marshal all material culture toward the maintenance of the way things are. Yet we also know that cultural production can also challenge capitalism, statecraft, patriarchy, and all the systems used to produce disparity. With *Signal*, we aspire to understand the complex ways that socially engaged cultural production affects us, our communities, our struggles, and our globe.

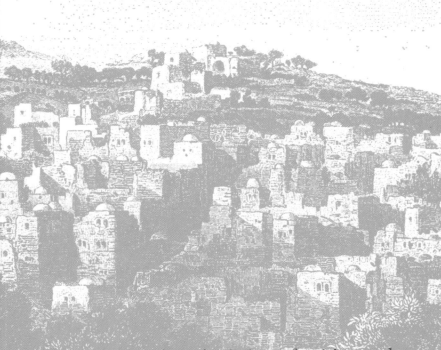

We welcome the submission of writing and visual cultural production for future issues. We are particularly interested in looking at the intersection of art and politics internationally, and assessments of how this intersection has functioned at various historical and geographical moments.

Signal can be reached at: editors@s1gnal.org

شؤون فلسطينية

ايلول (سبتمبر) ١٩٧١

٤

n.4/Sept. 1971

Imaging Palestine
The Artwork of
Palestinian Affairs

Rochelle Davis and Emma Murphy

The work of Palestinian artists appears in the homes and offices of every Palestinian, hung in framed reproductions on walls, reworked into school projects, and placed on the covers of Palestinian magazines, journals, and books. In most contexts fine art is the realm of the elite, but in the 1960s and 1970s, Palestinian artists joined the emerging Palestinian liberation movements and inserted the rich vocabulary of images they were part of developing into the struggle for Palestinian independence and self-determination. Artist Samia Halaby expressed that to be an artist in the 1960s was "the most political thing I can be as a Palestinian." Through their artwork, these artists participated in building and defining Palestinian culture, revolutionary struggle, and artistic taste. They regularly made posters and graphics for the liberation movements, and reproductions of their work were sold in bookstores and seen on street corners every day.

One of the reasons for the popular appeal of these artists' work was that they took the traditional imagery associated with Palestinian handicrafts, folklore, music, and poetry, and combined it with the potent symbols of Palestinian resistance. Using techniques and methods gained in their fine arts training, they created a new visual representation of Palestine in oil, watercolor, and gesso. The popularized usage of these fine art works was facilitated by accessible reproduction technology and the absence of copyrights.

n.6/Jan. 1972

n.8/April 1972

n.9/May 1972

One Palestinian journal, *Palestinian Affairs* (*Shu'un Filastiniyya* in Arabic), provided a showcase for the work of Palestinian artists from the early 1970s through the 1990s. It pioneered the use of fine art works as cover illustrations, and featured Palestinian—but also other Arab and international—artists and graphic designers who exemplify both the trends in representation of the Palestinian struggle and broader currents in the art and design of the era.

Palestinian Affairs was a publication of the Palestine Research Center (PRC), which was founded in 1965 by the Palestine Liberation Organization (PLO). The PRC began publishing *Palestinian Affairs* in Beirut in 1971 as a monthly journal that specialized in publishing articles and research related to politics, culture, economics, and international relations, along with monthly reports on Palestinian and Israeli issues. The cover art of *Palestinian Affairs* provides a window into the work of Palestinian artists during this period as well as the political events that shaped Palestinian history.

It is important to note that the political environment depicted on many of the covers of *Palestinian Affairs* affected the publication of the magazine itself. In September 1982, during the Israeli invasion of Lebanon, Israeli troops confiscated the records and library of the Palestine Research Center and carried them back to Israel, to be returned to the PLO later as part of a prisoner exchange deal. Although the PLO moved from Beirut to Tunis as a result of the Israeli invasion, the PRC continued its work in Beirut. In February 1983, the PRC was the target of a car bomb that killed eight employees. These events and harassment by the Lebanese authorities pushed it to relocate to Nicosia, Cyprus, in the summer of 1983. The PRC published 245 issues of *Palestinian Affairs* from 1971 until September 1993, when it was closed for financial reasons. In 2011, Palestinian Authority President Mahmoud Abbas decided to revive the PRC and start publishing the journal again. To date, eight issues have been produced.

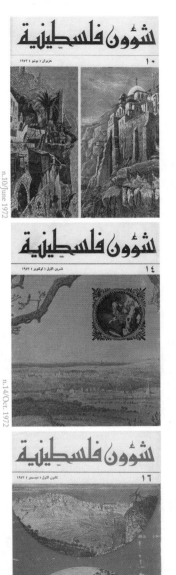

n.10/June 1972

n.14/Oct. 1972

n.16/Dec. 1972

شؤون فلسطينية

١٢

آب (اغسطس) ١٩٧٢

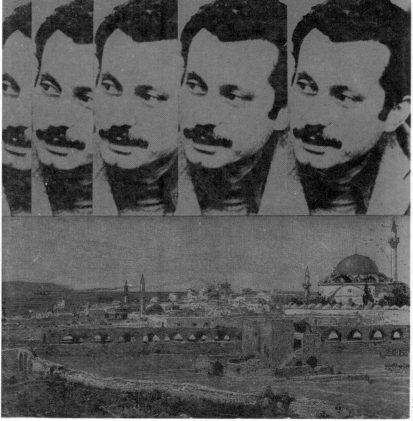

n.12/Aug. 1972

شؤون فلسطينية

ايلول (سبتمبر) ١٩٧٢

١٣

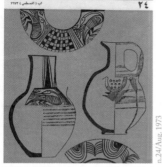

Art and the PLO

Artists' participation in the institutions of the PLO began with its founding in 1964. The Palestinian artist Ismail Shammout set up the PLO's Arts Section (*qism al-thaqafa al-faniyya*) in 1965 and drew in a broad swath of Palestinian artists, including those who were already members of the PLO and the resistance movements. According to artist and art historian Samia Halaby, in her study *Liberation Art of Palestine*, "The artists had become sufficiently organized by 1964 that one day after the meeting of the Palestine congress to establish the PLO, they opened an exhibition in al-Quds (Jerusalem) to celebrate the occasion. The show had such an impact that people began to think of art as part of the liberation movement."

In addition to heading the PLO Arts Section, in 1969 Shammout was elected president of the General Union of Palestinian Artists (*al-ittihad al-`am lil-fananin al-filastiniyyin*) and the Union of Arab Artists. The PLO also established an Arts and

Heritage Section, which was headed by Tamam al-Akhal, Shammout's wife and an accomplished artist in her own right. Pioneers in the world of Palestinian art, both al-Akhal and Shammout were incredibly prolific, and their art took on strong nationalist symbolism. This is the political environment for artists in which *Palestinian Affairs*, what became the PLO's main intellectual publication, created its covers.

Born in the coastal city of Lydda (Lyd/Lod) in 1930, Ismail Shammout was trained in his hometown by artist Daoud Zalatimo. Following the 1948 war, Shammout worked as a street vendor in a Gaza refugee camp prior to moving to Egypt, where he attended art school. Over his long career and involvement with the PLO, Shammout's work both drew on and simultaneously helped create the visual symbolic vocabulary of Palestinian nationalism. The dynamic flow of his canvases contrasts with the more static and stationary images of similar subjects that other artists pictured (see n.129–131, 1982; n.208, 1990; n.221–222, 1991).

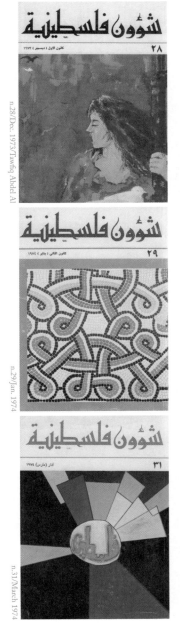

n.28/Dec. 1973/Tawfiq Abdel Al

n.29/Jan. 1974

n.31/March 1974

n.33/May 1974/Ismail Shammout

n.34/June 1974

n.41–42/Jan.–Feb. 1975

Tamam al-Akhal (b. 1935 in Jaffa) was trained in Lebanon and Egypt, and is both an artist and an art educator. She maintains that she first started painting realistic representations of life and landscape, then shifted to painting "stories of Palestinian heritage" using "the historical style of Arab painting." Her art was used on the covers of almost a dozen issues, each deploying different aspects of her work, from abstracted scenes from refugee camps to recreations of embroidery (n.158–159, 1986) to detailed mythological representations of Palestinian landscapes.

The Early Years

For many Palestinian artists, their work is a means of voicing the struggles of their people. As evident in the selection of artwork chosen for *Palestinian Affairs*, the ever-recurring visual theme is that of resistance. Through representations of armed struggle, symbols identified with Palestine, and depictions of daily life, artists conveyed this sentiment through a nationalist lens. Additionally many artists faced censorship of their

شؤون فلسطينية

٢٧

تشرين الثاني (نوفمبر) ١٩٧٣

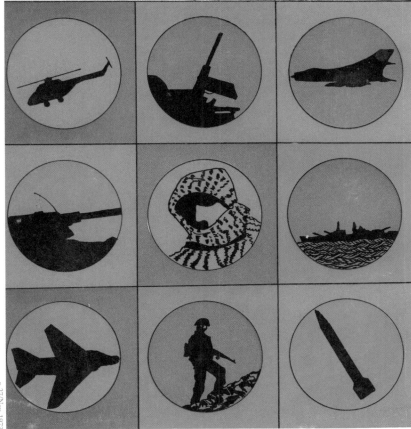

شؤون فلسطينية

تموز (يوليو) ١٩٧٤ ٣٥

n.35/July 1974

work in Israel, the destruction of their art, and even imprisonment. Sliman Mansour once asserted that he "cannot even paint a watermelon," due to its sharing colors with the Palestinian flag. This repressive context led many to leave their work unsigned.

The early covers were graphic and illustrative in block colors with abstract images hinting at subjects Arab and Palestinian in their use of arabesques, symmetry, and the curves of calligraphy (see n.3, n.4, n.5, 1971, and n.6, 1972). Josh MacPhee, in his blog on political book cover design on Justseeds.org, describes these graphics in which "the clean masthead and limited palette combine with the classical print imagery to generate a very clean, efficient, and almost conservative design." Other covers include more overt selections from Palestinian history and culture, such as issue 26 (1973) with its imagery of embroidery from a Palestinian dress overprinted with a vibrant fuchsia wash. In an act of reclaiming the history of the area, redrawn images of Philistine pottery from the second millennium BCE appear on the cover of

n.44/April 1975

n.48/Aug. 1975

n.49/Sept. 1975

شؤون فلسطينية

تشرين الأول (اكتوبر) ١٩٧٤

٣٨

شؤون فلسطينية

٤٥ ايار (مايو) ١٩٧٥

n.50–51/Oct.–Nov. 1975/Jumana al-Husseini

n.52/Dec. 1975

n.56/April 1976

issue 24 (1973). The Philistines predate the biblical history of the region and are the sources of the names "Palestine" (English) and "Filastin" (Arabic) to refer to the land. The early covers include reworked selections from the lithographs of Europeans who traveled in Palestine in the mid-1800s (n.8, n.9, n.10, n.12, n.13, n.14, n.16, 1972).

The early *Palestinian Affairs* cover designers also placed images and designs related to current events on the covers. Issue 12 from August 1972 features repetitive images of the writer, novelist, artist, and activist Ghassan Kanafani placed above a colorized reproduction of the city of Acre, where he was born in 1936. The cover commemorated his assassination in July of 1972 in Beirut by a bomb planted in his car, allegedly by the Israeli Mossad.

Less than a year later, issue 27 from November 1973 shows the armaments of the October 1973 war in which Syria and Egypt coordinated a surprise attack on the Golan Heights and the Sinai to regain their lands occupied by Israel in the 1967 war. The cover illustrates one of the largely forgotten

elements of the war: that Israel only repelled the attack and regained lost ground after the United States provided them with heavy arms. Pictured here is a Palestinian *fida'i* (fighter) surrounded and locked in by the armaments of the countries that fought the war and the weapons with which they were supplied by the U.S. and others.

Neither artist nor cover designer is noted on the first twenty-seven volumes. The first use of a signed work is a painting by Tawfiq Abdel Al, featured on the cover of issue 28 from December 1973. Born in 1938 in the coastal city of Acre, he fled with his family to Lebanon in 1948, where he spent the rest of his life (d. 2002). He described his early work as "an abstract, impressionistic style" using the clear colors of pastel chalks with which he learned to draw. The cover of issue 28 features an abstraction, in the background and on the woman's dress, which then coalesces into a portrait of a female *fida'i* holding both a rifle and a dove

The written word appears in the artwork on a number of different covers, drawing on a long history of calligraphy

n.58/June 1976

n.59/July–Sept. 1976/Mona Saudi

n.61/Dec. 1976/Mona Saudi

شؤون فلسطينية

تشرين الاول / تشرين الثاني
(اكتوبر / نوفمبر) ١٩٧٦

٦٠

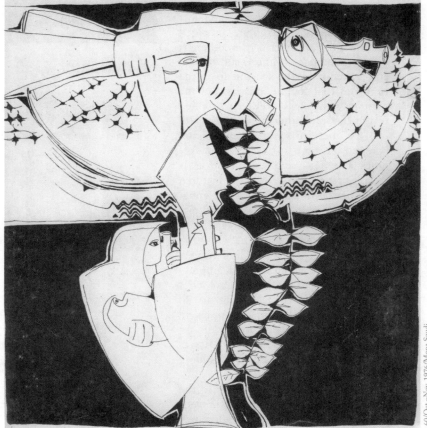

شؤون فلسطينية

٦٢
كانون الثاني (يناير) ١٩٧٧

as a graphic element in Islamic art as well as in modern Arab art (see n.76, n.102, n.111, n.126, n.196). The unattributed artistic rendering of the word "Jericho" on issue 34 (1974) references this city in the Jordan Valley as both the oldest urban settlement in the world and one that played host to hundreds of thousands of refugees following both the 1948 and 1967 wars. Rendered in youthful colors, with flowers and suns, its full letters fill the frame and make it contrast with the much more serious and rigidly rule-based calligraphy used on signs and in manuscripts.

The calligraphic use of the vocabulary of Palestine and the Palestinian revolution appears in the cover work of a number of artists, most prominently Kamal Boullata (b. 1942 in Jerusalem). Three examples of his strong graphic language can be found on issue 62 in 1977 ("The 12th anniversary of the start of the Palestinian revolution, 1965"), issue 94 in 1979 ("Victory"), and issue 215–216 in 1991 ("Revolution-Richness"/"Thawra-Tharwa").

Boullata's work, although utterly modern in its conception, messaging,

شؤون فلسطينية

٩٢/ ٩٣ تموز /اب (يوليو / اغسطس) ١٩٧٩

شؤون فلسطينية

اذار (مارس) ١٩٨٠ ١٠٠

n.100/March 1980/Samiya Subaih

and layout, harks back obliquely to Palestinian heritage. Boullata, an artist and a prominent historical authority on Palestinian art, works in an abstract geometric and symbolic style. Before immigrating to the United States to complete his studies, he was trained in the tradition of Byzantine icons under Jerusalem artist Khalil Halabi. Boullata's designs refract the interlacing loops of calligraphy but also evoke the Hellenistic, Byzantine, and Islamic-era mosaics composed on the floors of churches, mosques, and other buildings throughout Palestine (see n.23, 1973 and n.29, 1974). The multiple angles and layers of color and line that are emblematic of Palestinian embroidery also illustrate *Palestinian Affairs*. The cover of issue 20 (1973) is rendered as a colored sketch of a fabric pattern.

Michel Najjar—whom we have been able to find little about, so this is possibly a pseudonym—created similar covers using calligraphy embedded in a folkloric form. On the cover of issue 111 (1981), the motifs that appear in the commonplace flat woven basket articulate the word "Palestine," which

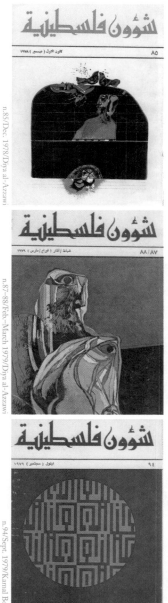

n.85/Dec. 1978/Diya al-Azzawi

n.87–88/Feb.–March 1979/Diya al-Azzawi

n.94/Sept. 1979/Kamal Boullata

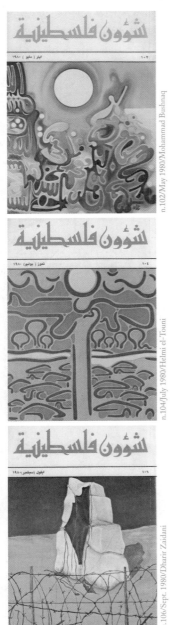

شؤون فلسطينية

ايار / مايو ١٩٨٠

n.102/May 1980/Mohammad Bushnaq

شؤون فلسطينية

تموز / يوليو ١٩٨٠

n.104/July 1980/Helmi el-Touni

شؤون فلسطينية

ايلول /سبتمبر ١٩٨٠

n.106/Sept. 1980/Dharir Zaidani

is mirrored four times in the squares in the center, with "revolution" featured repetitively in two bands around the outside.

Rather than simply defaulting to the masculinist militarism of so many political publications of the era, these covers are profound because of how deeply they draw on symbols of Palestinian daily life—the historical ruins that dot the landscape, the folkloric forms, and women's embroidery. Architectural and human environments of Palestinian villages, towns, and cities are also used as inspiration by artists such as Sliman Mansour (n.104, n.105, n.110, n.127), Ibrahim Hazimeh (n.172–173, n.225–226), Leila Shawa (n.174–175), Nabil Anani (n.168–169), and Jumana el-Husseini (n. 50–51, n.74–75, n.107). For many of these artists, the landscape and material culture that surrounded them in Palestine served to provide material for their designs, motifs, and palettes—emphasizing, while also creatively reworking and reimagining, the connections of Palestinians to their history and land.

GUPPA and Internationalism

In the late 1970s and 1980s, the covers of Palestine Affairs reflected a new relationship with the General Union of Palestinian Plastic Artists (GUPPA) and featured GUPPA artists' work on its covers. GUPPA grew out of the Palestinian Fine Arts Section (*qism al-funun al-tashkiliyya*, also called the Plastic Arts Section), which was established by the PLO in 1977. At the time, GUPPA was under the direction of Mona Saoudi (b. 1945 in Amman, Jordan) a sculptor who studied at the École des Beaux-Arts in Paris.

During this period the covers of *Palestinian Affairs* expanded to include artists from all over the Arab world and beyond, drawn from joint exhibitions and solidarity work with Palestinians. Works featured in the International Art Exhibit for Palestine, organized in 1978 by the PLO, provided many covers for the journal. For example, the work of Moroccan artist Mohammad Chabaa used on the cover of issue 77 (1978) echoes Palestinian themes—the key symbolizing the right of return and

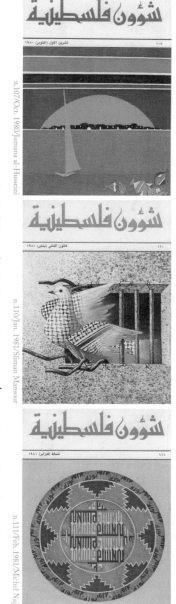

n.107/Oct. 1980/Jumana al-Husseini

n.110/Jan. 1981/Sliman Mansour

n.111/Feb. 1981/Michel Najjar

شؤون فلسطينية

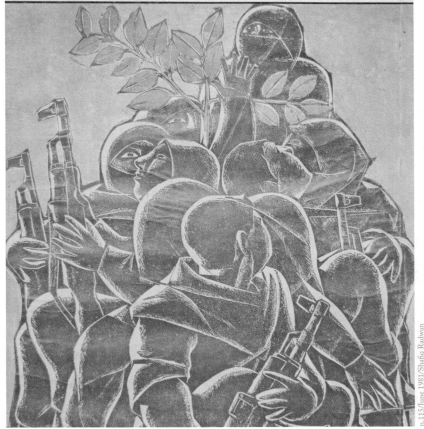

شؤون فلسطينية

آذار (مارس) ١٩٨٢ ١٢٤

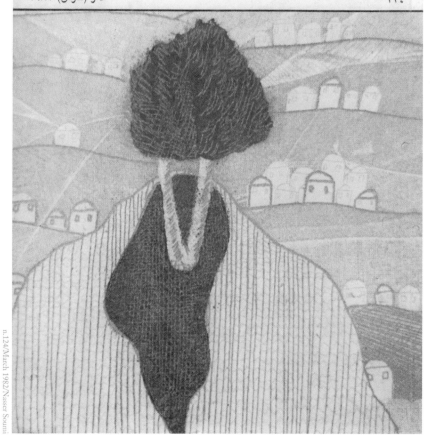

n.124/March 1982/Nasser Soumi

شؤون فلسطينية

١٤٤ ـ ١٤٥ آذار / نيسان (مارس / ابريل) ١٩٨٥

n.144–145/March–April 1985/Dhahir Zaidani

شؤون فلسطينية

تموز (يوليو) ١٩٨٩ ١٩٦

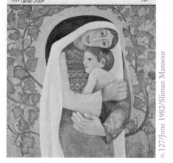

the *kefiya* (the black and white check-ered scarf) symbolizing Palestinian resistance. Iraqi artist Diaa al-Azzawi created covers for many issues in the late 1970s. His surreal painting of a rider on a horse on issue 87–88 (1979) obliquely connects to the struggle with its use of the white horse, a symbol of the Palestinian revolution. Surrealism and other modernist art movements are a strong influence on this era of covers, including issue 95 (1979) which fea-tures a painting by the German artist Max Ernst and Lebanese artist Emile Menhem's almost futurist cover for is-sue 92–93 (1979).

The twenty-year arc of the jour-nal's covers reflect a great range of artistic themes, styles, and symbols, paralleling the renaissance and subse-quent development of Palestinian art and culture that began in the 1960s and was aided by the founding of the PLO. Tawfiq Abdel Al notes the shift in his style from direct images to the more symbolic: "When the PLO was established, I switched from painting fighters to painting horses and my style became more surrealistic, with

the sun playing a huge role in my canvases, along with birds, horses, and roosters." His shift in style mirrors what many Palestinians felt with the establishment of the PLO—that they had created a body that represented them and the tangible manifestation of their struggle for political rights, and thus they themselves felt liberated to pursue other ways of expressing themselves and of choosing imagery and styles. Over the two decades of its existence, *Palestinian Affairs* captured these trends and diversity in their covers, providing a retrospective view onto the changing relationship between artists, their work, and Palestinian liberation movements. ⑤

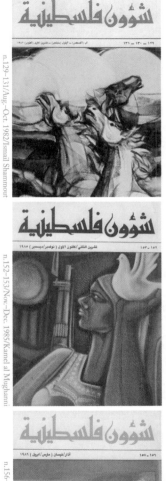

n.129–131/Aug.–Oct. 1982/Ismail Shammout

n.152–153/Nov.–Dec. 1985/Kamel al Mughanni

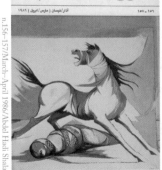

n.156–157/March–April 1986/Abdel Hadi Shala

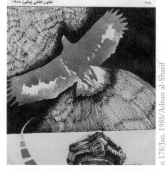

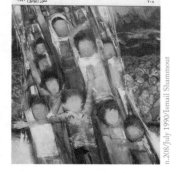

n.158–159/May–June 1986/Tamam al-Akhal

n.178/Jan. 1988/Adnan al-Sharif

n.208/July 1990/Ismail Shammout

For additional information:

—All of the covers published here are from the collection of the Institute for Palestine Studies and are located digitally in the Palestine Poster Project Archive (http://www.palestineposterproject.org/publisher/Palestine-research-center-prc). The authors are grateful for the Archive, its open source policy, and Dan Walsh's incredible curation efforts.

—For additional information on the PLO Arts Section and other Palestinian arts organizations, see Samia A. Halaby, *Liberation Art of Palestine* (New York: H.T.T.B. Publications, 2003): http://alwanalteef.blogspot.com/2010/09/1967-1994.html

—For more information on Palestinian art, see Kamal Boullata, *Palestinian Art: From 1850 to the Present* (London: Saqi, 2009) and Rasha Salti, "Of Dreamers, and Palestine's Revolutionary Posters," in *Manifesta Journal* #16: http://www.manifestajournal.org/issues/regret-and-other-back-pages/dreamers-ezzeddine-qalaq-and-palestines-revolutionary-posters#

—For additional information on the U.S. supplying Israel with weapons during the 1973 war, see the U.S. Department of State website: http://history.state.gov/milestones/1969-1976/ArabIsraeliWar73

—The current issues of *Palestinian Affairs*, published in Arabic, available here: http://www.shuun.ps/

شؤون فلسطينية

٢٢٥ ـ ٢٢٦ كانون الأول (ديسمبر) ١٩٩١ ـ كانون الثاني (يناير) ١٩٩٢

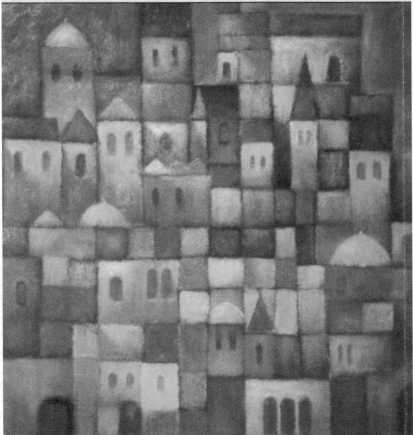

FIGHTING FIRE WITH WATER
THE BAY AREA PEACE NAVY'S LARGE-SCALE VISUAL ACTIVISM
LINCOLN CUSHING

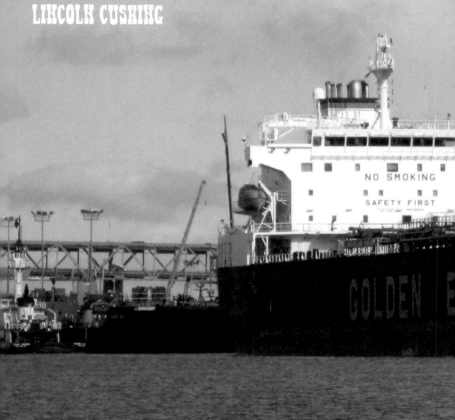

NO SMOKING

SAFETY FIRST

GOLDEN

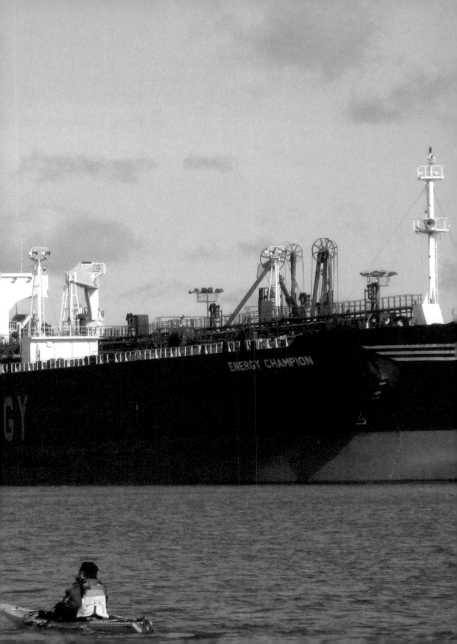

"We've got to face the fact that some people say you fight fire best with fire, but we say you put fire out best with water. We say you don't fight racism with racism. We're gonna fight racism with solidarity." —Fred Hampton, Chicago, February 14, 1969

When speaking truth to power, you have to strategically use all your tools. In the San Francisco Bay Area, one cannot ignore that a major venue for activism is the glorious bay itself. So, on May 30, 1983, a small group from the American Friends Service Committee (AFSC) launched a water-borne action at Port Chicago to protest the U.S. Navy's arms shipments to Central America. It almost ended in disaster—Pentagon Papers hero Daniel Ellsberg's nine-foot sailboat came close to sinking—but it was our salvo over the bow. The Bay Area Peace Navy was born.

The Peace Navy was picking up the baton in a long line of water-based political activism. In 1958 the U.S. yacht *Phoenix of Hiroshima* sailed into the forbidden Bikini Atoll nuclear test zone in the Pacific to protest U.S. nuclear testing. Another vessel, the *Golden Rule,* was stopped and its crew was arrested; it is currently being lovingly restored with the support of Veterans for Peace. Four years later Kaiser Permanente physician Dr. Monte Gregg Steadman and crew deliberately sailed their 38-foot ketch *Everyman II* from Honolulu into the harm's way of the Johnson Island atomic tests; their ship was seized and the men held in contempt of court. More recent examples include Pete Seeger's sloop *Clearwater,* an icon for the ecological restoration of the Hudson River, and the well-known efforts of Greenpeace's *Rainbow Warrior* ships.

During the Vietnam War, people used their boats to make their point. Quaker peace activist David Hartsough—an organizer

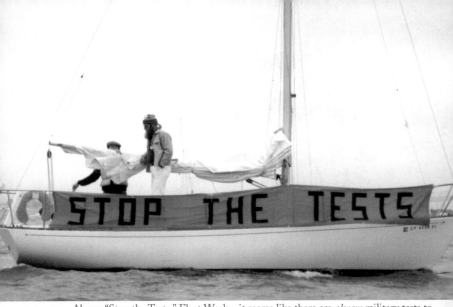

Above: "Stop the Tests," Fleet Week—it seems like there are *always* military tests to challenge, 1986; previous page spread: The Peace Navy joined Direct Action to Stop the War at Chevron's Richmond Refinery to demand that Chevron stop contributing to global warming, the war in Iraq, and releasing pollution in Richmond and beyond, 2008; photos: Lincoln Cushing.

of the 1983 AFSC demonstration and a Peace Navy member—recalls an action in 1972 at the Earle Naval Ammunition Depot in New Jersey:

We had twenty-two canoes lined up, with at least two people for each, and the news that a ship named the *U.S.S. Nitro* was on its way to the base. We left from the beach early in the morning and paddled in a flotilla out to the pier, where crates of munitions were stacked. We got close enough to read cartons labeled "Napalm" and "Anti-personnel weapons." Seeing those really tore me apart. They meant sure death for people in Vietnam, and I felt even more strongly that we had to do everything we could to stop them from reaching their destination. For six days we paddled around in our boats, as the mountain of weapons on the *Nitro* grew and grew. One canoe was sunk when

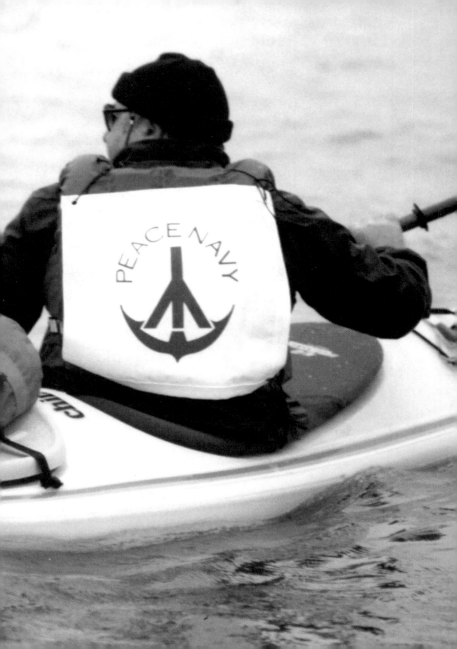

a police boat revved its engine nearby to flood it with water, and another when an MP pushed its prow underwater with a grappling hook. When the *Nitro* finally lifted her anchor and we paddled our canoes hard to block it, seven sailors jumped off the ship to join our blockade. We like to think that our courage gave courage to the sailors to do what their consciences were telling them to do and their courage gave a lot of courage to many other U.S. military personnel to resist their participation in the war.

Since 1983, the Peace Navy has engaged in a rich variety of water-based guerrilla theatre dramatizing our opposition to U.S. Naval intervention abroad and support for ecologically sound, socially just, and peaceful uses of the bay at home. Peace Navy founder Bob Heifetz put it this way:

Our events use humor and satire to express our views depicted by the beauty of small and larger boats festooned with banners and sails carrying our message to targeted audiences. We see ourselves as a cross between the theatrics of the San Francisco Mime Troupe and the direct action dramatizations of Greenpeace. We work with peace, ecology, labor, and social justice groups.

Although our ability to mobilize on the water has declined in recent years, the Peace Navy has successfully occupied a niche in the political ecology with its vibrant cultural forms.

Our most consistent actions were organized against Fleet Week, a giant party held mid-October for the U.S. Navy and Marines sponsored by City of San Francisco and the Navy League. The Blue Angels, the Navy's exhibition team of F/A-18 Hornets, streak overhead and local dignitaries greet giant warships as they parade through the Golden Gate. It's an enormously popular event.

The current incarnation of Fleet Week has only been around since 1981, when then-mayor Dianne Feinstein established it as an annual event. She was resurrecting the patriotic glory of Fleet Week, July 1908, when San Francisco proudly hosted President Teddy Roosevelt's "Great White Fleet" and provided an ample venue for

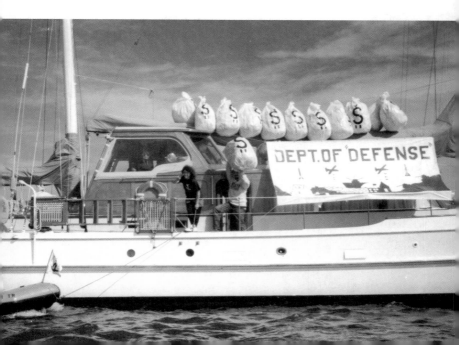

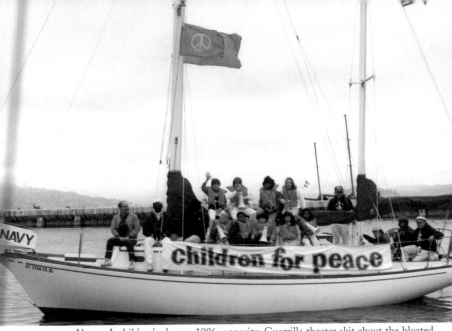

Above: A children's chorus, 1986; opposite: Guerrilla theater skit about the bloated military budget, 1997; previous page spread: Vessels and banners of all sizes make a proud peace fleet, 1986; photos: Lincoln Cushing.

crowing about our conquest of the Philippines. They still bring out the big gunboats, but the Peace Navy was there to counter the jingoism with singing children, giant banners, clever slogans, drum circles, and theater.

Who was our audience? During Fleet Week, we passed stands full of dignitaries, politicians, and the general public. We also came close to the Navy and Coast Guard ship crews and we'd occasionally get some press coverage, but rarely; Fleet Week was sacred to the media. We coordinated water-borne actions with our allies (such as AFSC, Greenpeace, and the Committee in Solidarity with the People of El Salvador) on the shore, who handed out fliers to better explain why these unpatriotic wingnuts in a ragtag flotilla were ruining the parade.

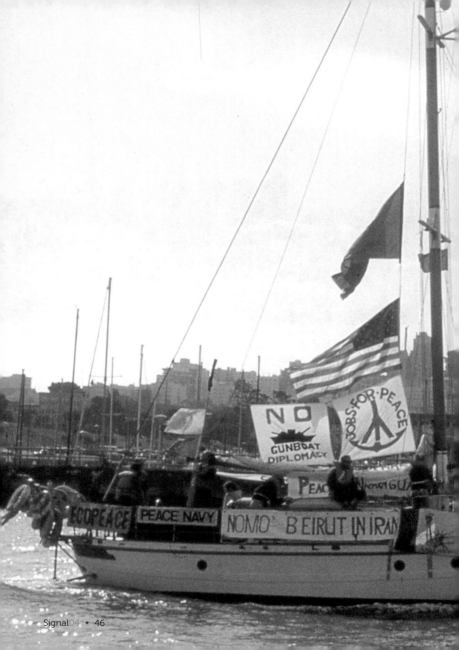

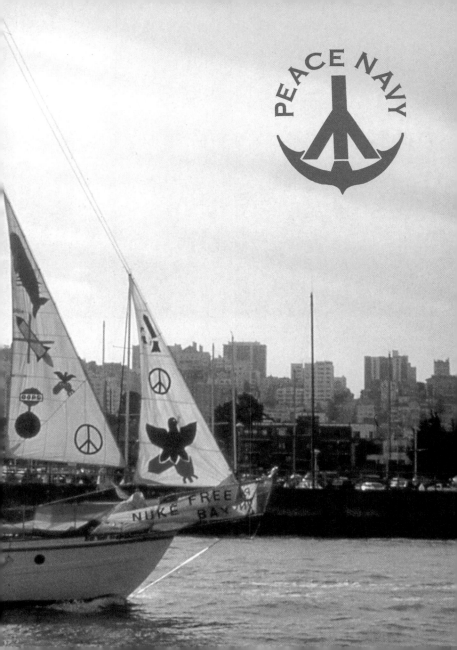

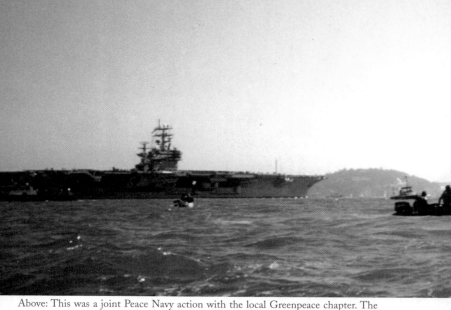

Above: This was a joint Peace Navy action with the local Greenpeace chapter. The inflated "loaf of French bread" was used to protest French nuclear testing in the

We were pushy. Perhaps our greatest legacy was a lawsuit that resulted in a landmark ruling that expanded the terrain of public demonstrations, *Bay Area Peace Navy v. United States*, 914 F.2d 1224, 1229 (9th Cir. 1990). We successfully challenged an arbitrary security zone that diminished the efficacy of water-borne protests. A legal summation of the case described it this way:

The intended audience was the group of invited individuals who were interested in the Navy procession and therefore, the demonstrators apparently presumed, harbored views about the importance of military preparedness different from those of the demonstrators. We considered whether a restriction preventing the Peace Navy from getting within 75 yards of their intended audience was a valid time, place, and manner restriction on speech, and held that it was not. The restriction did not leave the speakers with an

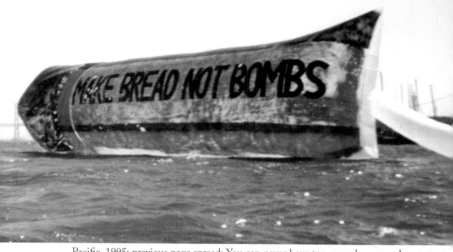

Pacific, 1995; previous page spread: You can never have too many banners when out on the water, 1999; photos: Lincoln Cushing.

ample alternative for communicating their message to the intended audience, the last prong of the time, place, and manner analysis as traditionally stated. From 75 yards away the audience could neither see the protestors' banners nor hear their singing.

Our usual Fleet Week demonstrations amassed flotillas of small and large craft and focused on a different theme each year. Issues included the controversial homeporting of the battleship USS *Missouri*, the centennial of the Spanish-American War, and challenging the bloated military budget. But our most ambitious effort was in 1995, when we called attention to French nuclear testing in the South Pacific. Under the guidance of artist Richard Kamler, the Peace Navy built a huge (17 feet by 75 feet) inflatable polyethylene loaf of French bread with the slogan "Make Bread Not Bombs."

D. Minkler 1989

Fleet Week makes me sick
I'm joining the Peace Navy

For more information contact; BAY AREA PEACE NAVY
1009 Oxford Street, Berkeley, CA 94707
(415) 398-1201

My lead Peace Navy boat carried a gasoline-powered blower, and a Greenpeace Zodiac took care of guiding the display in front of the review stand. This was not an easy task; we had to coordinate both boats that were delicately linked by an inflation tube, and the giant loaf wanted to roll and blow downwind.

The Peace Navy engaged in other actions as well, both at the request of local organizations and on suggestion from our members. In 1983 we protested the U.S. invasion of Grenada, done under the pretext of saving American medical students, by launching our own invasion of Angel Island "to save the deer." The next year we drew attention to the U.S. government's illegal mining of Nicaragua's harbors by symbolically "mining" the Alameda Naval Air Station with giant weather balloons. In 1985 we sailed a picket line by the *Nedlloyd Kembla*, a ship carrying goods from South Africa, in support of the longshoremen who were refusing to unload the ship's cargo. And in 1986 we joined fishers and the ecology movement to give visual testimony opposing offshore drilling at a public hearing. In 2008 the Peace Navy joined with numerous activists and artist David Solnit to protest the Chevron oil refinery in Richmond, California.

As the local military budget waned and bases closed, we figured that at least on the Fleet Week front we had "won." Unfortunately, it continued as ever. In 2001 our dedicated commander Bob Heifetz passed away, further taking the wind out of our sails. It was not until the 2013 federal budget "sequestrations" that we saw the unprecedented (but temporary) elimination of the Blue Angels, Fleet Week's most popular draw. Our op-ed in the *East Bay Express*, a local alt-weekly newspaper, outlined our challenge, comparing our Fleet Week unfavorably to another similar event:

Seattle's Seafair features the Angels—as well as hydroplane races, pirate parades, marathons, fishing fleet parades, dragon boat races, and numerous community events. In contrast, Fleet Week is purely a homage to a Navy that once played a major role in the Bay Area but is no longer here.

That focus ignores the many other watermen and women of this magnificent region that deserve a broader celebration. The time couldn't be better to reexamine and redefine Fleet Week. Please join the many groups that are working to convert this event and return the bay to the people.

The Peace Navy made, and may continue to make, a contribution to the rich history of water-based social justice demonstrations. Movements should draw upon activists from all quarters, and we mobilized people who owned, or had access to, any form of watercraft. The logistics were challenging and the barriers—including failed engines, contrary tides, busy work schedules, and Coast Guard harassment—were daunting. But our efforts boosted morale of those engaged in land-based actions, and provided one more channel to challenge a military-industrial status quo.

We hope that others help pick up the baton as we did in 1983. Remember, you are only up the creek if you don't have a paddle. And you *can* fight fire with water. Ⓢ

Below: The author and son, Fleet Week 1999, photo: unknown; opposite: Greenpeace and Peace Navy with USS *Missouri*, 1987, photo: Janet Delaney; previous page: Doug Minkler's Fleet Week poster, 1989.

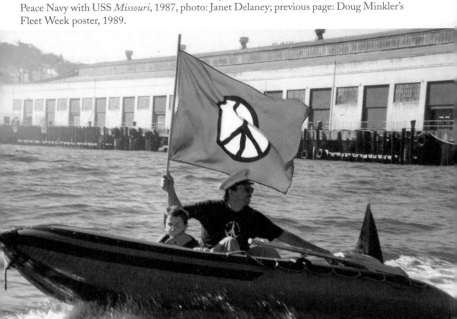

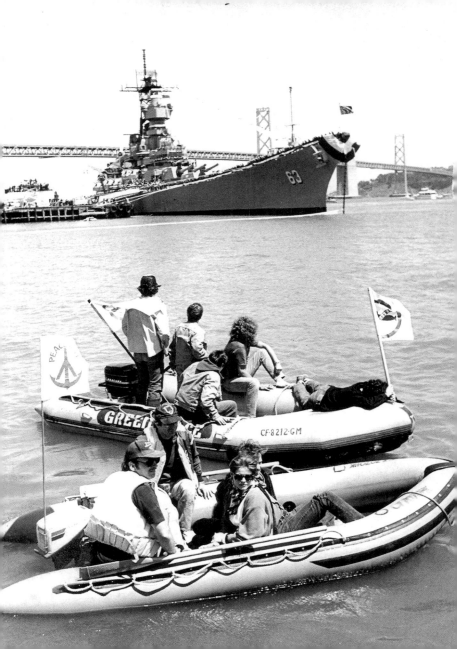

LAS PAREDES HABLAN AUNQUE LOS MEDIOS CALLAN

THE WALLS SPEAK EVEN IF THE MEDIA IS SILENT

BY TENNESSEE WATSON

In December 2012 I traveled to the border community of El Paso, Texas, and Ciudad Juárez, Chihuahua, to collaborate on a public memorial with a group of artists from Mexico, Canada, and the United States.

The memorial addresses the ongoing femicide—systematic murder of thousands of poor young women of color—in Juárez. Beginning in the early 1990s a global spotlight has been pointed at Juárez, largely because of successful

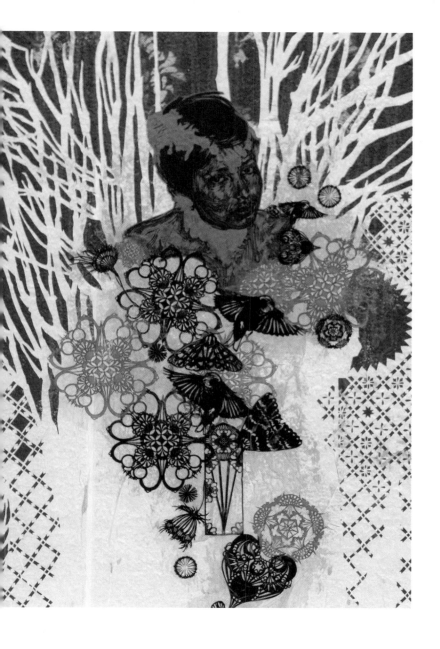

activism to draw attention there, but this kind of violence against women is happening throughout the Americas.

The memorial was a re-creation of a portrait that the artist Swoon and I first created in 2008, after traveling to Juárez and working with the community group Nuestras Hijas de Regresa a Casa. We met with mothers who had lost their daughters, and activists who were working tirelessly to bring the situation to public awareness.

Out of these meetings came "Portrait of Silvia Elena," a multimedia art memorial which took the form of a portrait by Swoon of a young woman combined with audio collages I had assembled from my recordings of conversations with mothers, and sounds from the vast patchwork of urban sprawl and desert surrounding Juárez.

Initially installed at the Yerba Buena Center in San Francisco and at Honey Space in New York, it was our intention to bring the piece to Juárez, but with the escalation of violence after our trip in 2008 we held off. Our contacts at Nuestras Hijas had gone underground after receiving multiple death threats

targeting them for their activism, and they eventually fled the city after the murder of several activists with whom they worked.

Knowing that we had the privilege to freely come and go from Juárez, we felt it was important to bring the memorial back, and to do so in the safest way possible for our Mexican collaborators. We wanted to use the work to continue to push for truth and justice about gender-based violence. From my distant vantage point—reading the headlines from Juárez that reached New York—the issue of femicide had been eclipsed by highly sensationalized stories of gun battles between narcos and the police. But we knew that amidst all the more sensational violence, young women were continuing to die as well. We specifically wanted to connect with local artists and to learn more about their participation in efforts to holistically address and resist violence in Juárez.

Leading up to our trip in December, we expanded the collaboration to include Halifax, Nova Scotia–based documentarian Andrea Dorfman and Juárez-based street artist WakaWaffles.

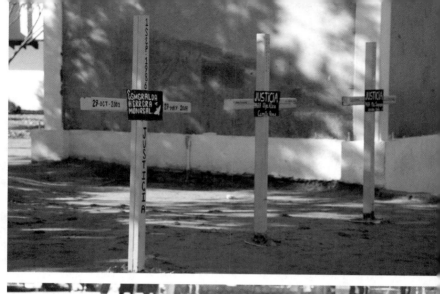

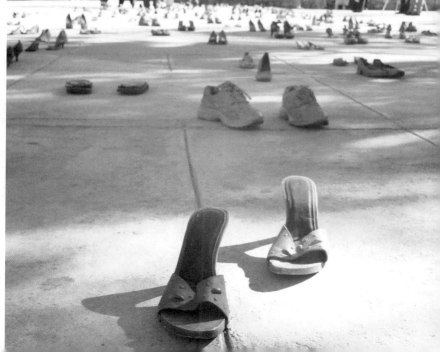

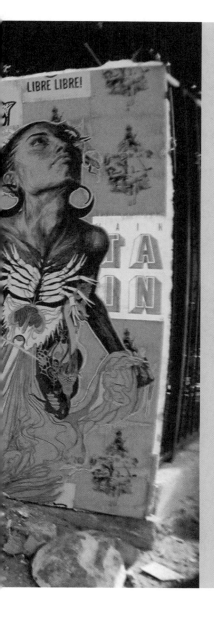

Upon arriving in Juárez we were joined by El Paso–based artists Christian Pardo Herrera and Ramon Cardenas from the Maintain Collective.

We spent two days painting and pasting up a new, collaborative version of our memorial next to Benito Juárez Plaza, the place where Silvia Elena Rivera Morales—the memorial's namesake—is thought to have disappeared while changing buses, and where many other young women have gone missing.

We also participated in an intervention organized by mothers of the disappeared where they placed hundreds of red shoes in front of the government agency responsible for investigation and prosecution, drawing attention to the government's lack of accountability or action towards justice.

Throughout our visit and through our continued conversations with artists in Juárez, it became ever more clear there was a need to make work that did not further stigmatize Juárez as a place of violence—but to recognize that this kind of violence, while it may seem isolated to a town on the other side of the U.S. border, is a situation born of socio-economic conditions that people in the

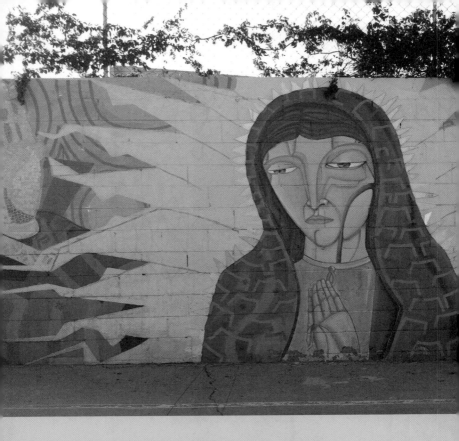

United States and Europe share a role in creating.

Collaborating with Juárez artists on street art about femicide serendipitously landed us at the intersection of other issues as well. It became apparent that our presence was encouraging and affirming to young activist artists in Juárez and El Paso, who despite facing violence and discouragement, had been making artwork about displacement on the streets of Juárez most threatened by gentrification.

The following are excerpts of conversations recorded with Christian, Waka, Swoon, and Andrea throughout the creation of the memorial, along with photos from Ramon and Andrea taken throughout the week.

Tennessee: **Waka and Christian, start by telling us who you are.**

Christian: **My name is Christian Pardo Herrera. I am Mestiza, born in Juárez from Indigenous and Spanish ancestry with roots in the south of Mexico, but I am a citizen of the world. I live in El Paso.**

Waka: **I'm Juan Carlos. They call me WakaWaffles. I'm not from Juárez, but I've been living here practically all of my life. I'm a graphic designer, but I mostly work as a muralist and stencil artist. As an artist who works in the streets, I really like the interactions I have with people and seeing their reactions. I like the idea that I am**

putting out a different message about this city.

Andrea: How do you see the city?

Waka: I love it, even though we live in this violent situation. We're right across the border so we've got this binational culture. We use this English-Spanish kind of "slanguage." It's kind of cool. Here you see a lot of influence from El Paso, and in El Paso you'll see a lot of influence from Juárez.

The situation in Juárez is bad, but it also brings artists from El Paso and Juárez together, and pushes us to work in new ways. When the violence really escalated artists didn't want to work in the streets, but we wanted to do something. We started doing workshops with kids—teaching them that they didn't have to be involved in bad things.

People are coming back out because we are tired of the violence, and tired of hiding. We're hosting events, selling art on the street, cooking food in the street, and giving workshops. We're trying to revive Juárez street culture, and it's fun to see how the community starts

to take over the streets. Those same kids from our workshops are tagging and sticking up stickers, people are learning to reclaim the streets again.

Tennessee: What is the history of art responding to the femicide?

Waka: The mothers of the disappeared have always used creative intervention. Look at the way they cover walls with missing person fliers. This is an artistic expression. It's paper fliers and packing tape, but it's a way to say to the government that they won't shut up, that they can't be ignored, that they are present.

They have become street artists unconsciously. I have always loved that. When I have the chance to talk to them I tell them they have a lot of courage to put up the posters on government buildings and place pink crosses throughout Juárez to keep the conversation about femicide going.

Tennessee: And it was those pink crosses that set this whole project in motion. I was on my way to Mexico City in 2006, passed through Juárez on foot,

and saw those crosses. Swoon, separately and a couple weeks later, had the same experience.

When we met each other in Mexico City we immediately started scheming about how to get back to Juárez. We returned together in 2008 to get a more nuanced understanding of what

was happening, and to make a piece about what we learned.

Swoon: We ended up making this portrait centered on the image of Silvia Elena Rivera Morales, the murdered daughter of Ramona Morales Huerta. Ramona is an amazing person

who has been super politically involved since the day of her daughter's disappearance.

Tennessee: Silvia Elena's disappearance was the case that tipped public awareness. And Ramona's activism along with other mothers pushed for a public recognition of what was happening as femicide. The mothers challenged the dominant narrative that the disappearances were just a random string of incidents happening to bad girls who put themselves in compromising situations. Instead, the mothers articulated a holistic understanding that took into account the socio-economic and political conditions at the root of the systematic murder of women.

Christian: It was interesting to me that while putting up the portrait of Silvia, both men and women were responding. I thought more women would be interested, but the men stopped and talked about how the violence against women affected them too. That was a good thing to hear.

Tennessee: Christian and Waka, you've both mentioned that you had rough childhoods, but that at some point your rebelliousness shifted into an artistic practice. Do you remember what caught your eye as a kid that made you want to be an artist?

Christian: Definitely! The street signs in Juárez. Every little store had their own unique painted signs—everything was hand painted. The signs are called "rótulos." I remember the buses used to be adorned with lights. It was all of that visual city culture in Juárez.

Tennessee: There was that older gentleman who stopped and helped us put up the paper cutout around Silvia's portrait. He seemed really into it. And he was an artist, right?

Waka: Yes. Coincidently he is a rotelista—one of the traditional sign painters.

Christian: He said art was like a never-ending story where you are always learning. He told me that he never imagined that you could use paper. He thought it was paint at first. He said: "Oh wow, it's a completely different world." I think it

has to do with changing the landscape.

The city has passed through this civil war. You can see it. It's marked-up. It's old and beat-up. This changes the visual landscape and the cityscape in a positive way. Street art brings color and characters that cause people to wonder. It changes the routine. I think that's an important aspect of the healing.

Waka: The place where we installed the work is important because it's where many people take the bus, and where many of these women went missing. This subject is really censored here in Juárez by the government.

I think it was really important to do it there because it's a reminder that there are still people who don't want to ignore it, and are still fighting for truth and justice.

Tennessee: What's been your experience emerging as artists in such a repressive environment?

Waka: There is a lot of police abuse toward local artists. You're not sure if you get caught whether you'll just go to jail, or if they'll disappear you.

Tennessee: And the cops are not the only source of fear, especially for women artists.

Christian: At a very early age I realized how women were being treated. As kids we'd be playing in the park, and some kid would come and say that there was a car looking for kids. You'd go home and look out the window and see this car going really slow. You're seven years old worrying about being raped; growing up with a certain fear about being a woman or growing breasts. For me puberty was hell. I hunched my shoulders and tried to hide my breasts. Now I have to force myself to stand up straight to counteract that.

I've heard these statements from guys in El Paso that women from Juárez are so hard. Of course I am. I come from across the border. You have to be watching your back all of the time. It changes you and the way you interact with people. It's so weird crossing

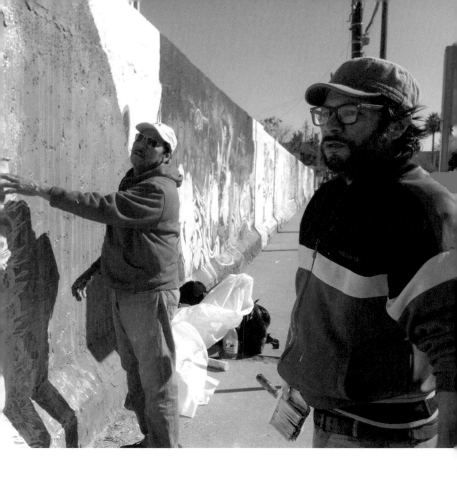

the border. Everyone is so chill in El Paso—so relaxed. They don't understand the source of my urgency.

I left Juárez for El Paso at the moment when it was about to explode with violence, but a lot of my friends stayed

and experienced dead bodies hung from bridges or heads being found all around town. Originally bodies were found on the outskirts, but then they were left in more urban areas. There's a lasting physical and psychological impact

of experiencing that level of anxiety when you're young.

Tennessee: And yet given all the repression and violence you both still want to make art?

Christian: I've processed a lot of my experience through art. I realized that my body is mine. If I want to feel sexy, I should be able to. It was an intense way to grow up; being constantly aware of the way your gender and your body put you in danger—physically and psychologically.

Getting into art and knowing about other women artists has been very important for me. To see women working, talking and making themselves be heard pushed me to realize that I could take what I'd been through and channel it through my artwork. I also realized I wasn't the only one. I started making all these connections and realizing that it's so much bigger than just me.

Swoon: So many times in my life I've given myself permission by seeing another person take action. If you can,

then so can I. With every piece of street art we pass that message: You can. And you can. And you can.

Tennessee: While we were working on the wall a couple of mothers of disappeared women happened to be waiting at the bus stop across the street. What was their reaction?

Christian: They thought it was wonderful that their daughters' stories were being presented through beauty. The piece isn't gory and doesn't sensationalize the violence. It's an act of respect and beauty. And in its process it's about human-to-human interaction outside of the influence of the government and other interests who want to quiet this issue. The mothers said they too would like to see their daughters on that wall— beautiful, strong, and smiling.

There is a need for a stronger bond between people. We don't need more hope in the government, or hope that officials will do what's right. We need to bring people together to act as a community. You don't always know how you'll

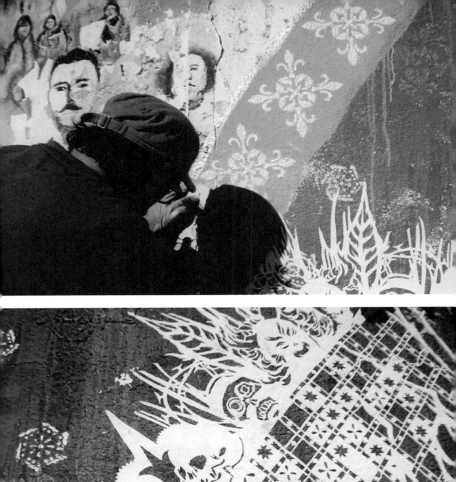

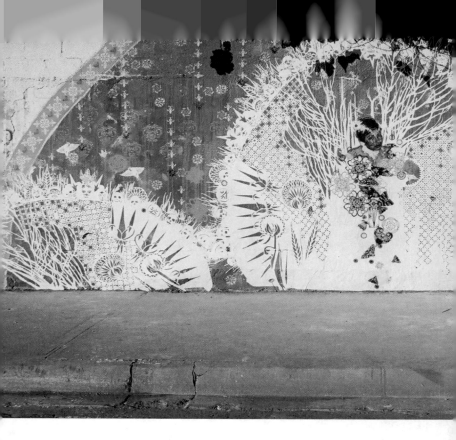

be received, but working on the street creates opportunities to connect. When I met the mothers we started hugging each other and crying. It was a really emotional moment.

Waka: As soon as I started painting on the street, I realized it was healing because it's a vulnerable process. It's not exclusive, it's not elitist. You're out there in public and people stop and ask you what you are doing. They might be on their way to work, in their daily routine, when they see you and stop.

I feel like I have to express myself or else I am just going to become part of this corruption. Sometimes I paint: *Que*

Thanks to Ramona
Morales Huerta.

PHOTO CREDITS

Ramon Cardenas,
Maintain Creative
Coalition
(main-tain.com)

Pages 58, 66, 71, 72-73.

Andrea Dorfman
(andreadorfman.com)

Pages 54-55, 57, 60-63,
65, 69, 173.

las calles hablen, que los medios callan
(The streets speak what the media
silences).

You have to be conscious. If we
ignore it then the situation will get
worse. We have to show what's really
happening, and not just hide it or
ignore it; otherwise we will continue
to experience oppression. We can't
keep quiet and be repressed. Ⓢ

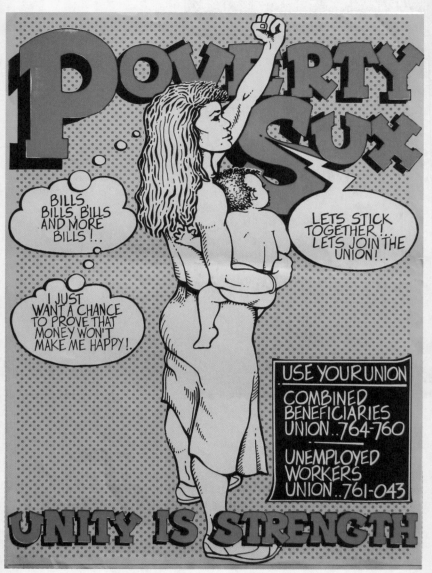

Poverty Sux, 1987, Karen Kahurangi.

Revolutionary Continuum:
Kotare Trust Poster Archive

by Jared Davidson

Never in history have the rich and powerful given up their privilege voluntarily. Part quote, part maxim, these were the words Kotare Trust asked me to illustrate in poster form in 2011. As well as helping the trust raise some funds, my screenprint was to accompany an exhibition of posters from their collection titled *Art/Movement: Political Poster Art in Aotearoa New Zealand.* The exhibit included public talks, screenprinting workshops, and a sample of the more than 500 works that make up the Kotare poster archive.

I had known about Kotare Trust through friends who had participated in their workshops, or had spent time in their Centre. Formed in the early 1990s by a collective of veteran activists, Kotare Research and Education for Social Change Trust offers just that—educational spaces to analyze and challenge injustice in its many forms. Through participatory adult education, research and creativity, Kotare aims to "inspire and

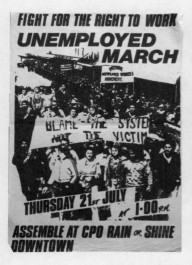

Fight for the Right to Work, 1988, Wellington Media Collective;
AUWRC, ca. 1980s, BW.

strengthen those striving for social, economic and environmental justice based on *Te Tiriti o Waitangi* (The Treaty of Waitangi) in Aotearoa New Zealand."

The poster archive is an important resource in Kotare's toolbox for social change. Despite a rich tradition of dissident art in Aotearoa, looking through the Kotare cache was the first time I had seen many of the posters, either in situ or online. There are few collections of radical posters in Aotearoa—some small clusters are scattered across various institutions, but Kotare is the only standalone radical poster archive. "Although Kotare Trust's support and networking across radical organizing, education, and research has helped us to build a poster and ephemera collection that is unique, it is not without its challenges," notes Sue Berman, Kotare trustee and resident archivist. "A heritage grant allowed us to buy a flat file and acid-free paper which was a great preservation leap forward.

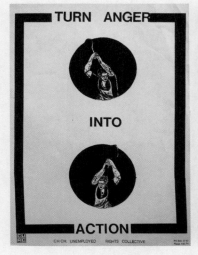
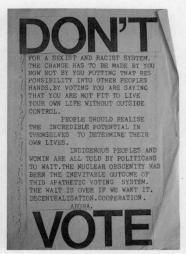

Turn Anger into Action, ca. 1980s, Christchurch Unemployed Rights Collective;
Don't Vote, ca. 1980s, artist unknown.

But the next obvious step to enable greater access will be to upload a photograph of each poster onto an online catalogue."

The poster archive covers numerous social movements, themes, and struggles dating from the 1970s. The histories of these movements are complex. Although some of the posters are specific to Aotearoa many will resonate with an international audience. The transnational influence of design, the universality of do-it-yourself culture, as well as the global nature of capital and the struggle against it means these posters can be placed in a wider social context without much explanation.

As a poster-maker and archivist, I am interested in the contextual layers associated with the Kotare poster archive. We know posters can be read on many levels, and that the relationship between maker and audience is continuously subverted and redefined—from simply consuming a given message to dialogical

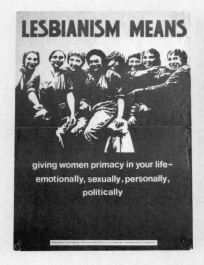
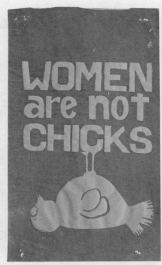

Lesbianism Means, ca. 1980s, Womens Action Collective of NZUSA; *Women Are Not Chicks*, 1980, artist unknown.

processes involving the viewer in the making itself. What struck me about the collection is how it makes accessible what Sue calls "the people behind the poster." Not just the poster-maker but the activist that pasted it to a lamppost, the printer who kept a spare copy, the archivist or institution that added their own provenance, and the student who used it to unlearn years of socialization. These voices have all influenced the posters Kotare now hold, and the metadata that exists.

I use the term "voices" deliberately. Sue is an oral historian and one of her goals with the *Art/Movement* exhibition was to collect more information about what Kotare held. "Younger generations attending workshops have often sought the stories behind the posters," says Sue. In response to this Kotare established an oral history project, which gathered a range of comments, from those who had made posters and activists whose struggles the posters aimed to

That Explains the Difference in Our Wages, 1980, Clerical Workers Union.

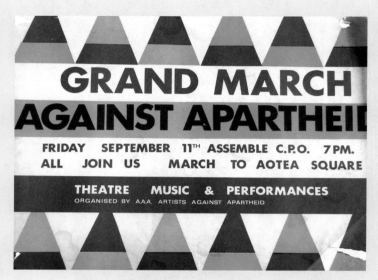

Grand March Against Apartheid, 1981, Artists Against Apartheid.

support. In many cases these participants were one and the same. At other times it was visitors to the exhibition who added further contextual information. In doing so, more layers of the posters' provenance were added to the collection.

The bulk of the posters come from within the Kotare community network itself, thanks to a desire to honor the struggles members participated in. The archive began with posters from the walls of the Auckland Unemployed Workers Rights Centre, formed in 1983. These posters reflect the initial neoliberal attacks on unemployment benefits, unwaged labor, and the welfare state during the late 1980s and 1990s. Many were created with no budget and in the spirit of grassroots activism—photocopied collages and hand-drawn fliers sit alongside accomplished woodcuts and full-color offset prints. Although the city of Auckland dominates, some of the twenty-eight other unemployed groups that were active nationally

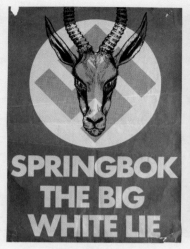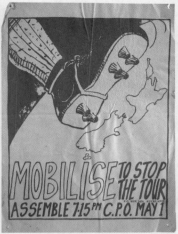

Springbok the Big White Lie, 1980, artist unknown;
Mobilise to Stop the Tour, 1981, Wallace Sutherland.

are also represented. These were augmented by posters from the Workers Educational Association, which illustrate associated themes of union struggle, equal pay campaigns, and summer schools and classes for workers. Feminist programs and women-only spaces were a feature of such classes, adding many posters that challenge capitalist patriarchy to the collection.

From the perspective of style and changing print technologies, some of the most interesting posters oppose nuclear testing in the Pacific, created by the movement to keep Aotearoa nuclear-free. *What Nuclear Family?* (1984) features a woodcut by artist Philip Clairmont, invoking Laurence Hyde's wordless novel *Southern Cross* (1951). A number of other posters in the collection are by prominent artists, especially those produced by trade unions or organizations that were lucky enough to receive funding. But these are less common than the cut-and-paste, hand-drawn posters that form the

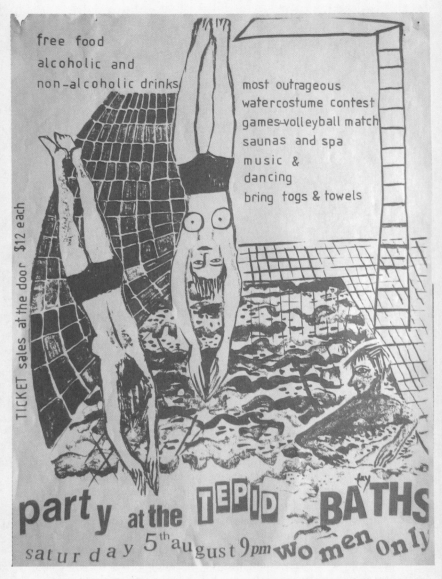

Party at the Tepid Baths, 1982, Fay.

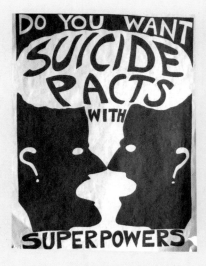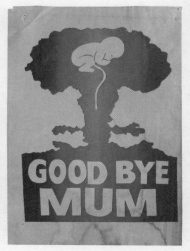

Suicide Pacts with Superpowers, 1982, Kate Hill;
Goodbye Mum, ca. 1980s, artist unknown.

majority of this collection. "Finding an artist willing to add graphics was a real bonus," recalls a participant in Sue's oral history project. "Doing a colour print run was a treat." An example of this is the split-fountain screenprint *Goodbye Mum* (1980s), whose artist remains unknown and the print-run was small. These more ephemeral prints (such as *Women Are Not Chicks*—a reworking of the original screenprinted in multiple colors by the Chicago Women's Graphics Collective) remind us of the precarious nature of street posters and the value of archives such as Kotare.

Posters decrying visits by South African rugby teams illustrate the highly divisive and ultimately successful struggle against apartheid. Although the racist polices of the South African government had been challenged by earlier boycotts, the protesting of the 1981 Springbok tour galvanized the general public in Aotearoa. A broad spectrum of people were radicalized by the experience, leading to

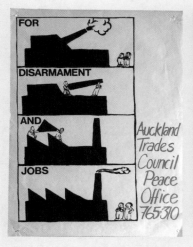
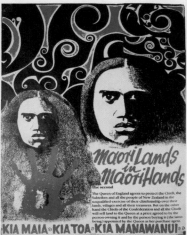

For Disarmament and Jobs, 1980, Auckland Trades Council Peace Office;
Maori Lands in Maori Hands, 1975, Robyn Kahukiwa.

a flurry of collectives (including Artists Against Apartheid), street battles with baton-wielding police, and the storming and occupation of sporting grounds (which was broadcast live to freedom fighters in South Africa).

The anti-apartheid movement, coupled with an indigenous movement growing in power and visibility, also led to an examination of racism and settler colonialism in Aotearoa itself. As depicted in Merata Mita's powerful documentary *Patu!* (1983), Maori activists challenged the movement to support *tino rangatiratanga* (Maori sovereignty and self-determination) and to question white supremacy within the left. Posters in the archive chart this development, as well as the shifting attitudes towards Te Tiriti o Waitangi—the means by which indigenous sovereignty was supposedly ceded to the British Crown in 1840. Statements like *The Treaty Is a Fraud* (ca. 1979) were later accompanied by "honour the Treaty," as many

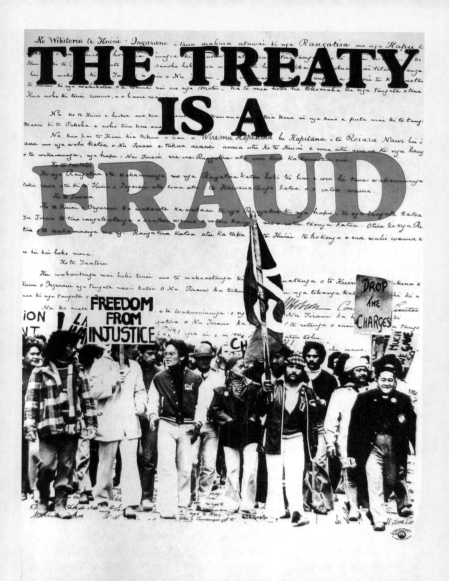

The Treaty Is a Fraud, 1979, artist unknown.

Working Art, 1985, artist unknown; *Art Auction, Art Action*, ca. 1981, Nigel Brown.

indigenous activists viewed the documents as strengthening—rather than extinguishing—Maori sovereignty.

There are also posters in the archive that speak to the importance Kotare places on creative activism, such as *Art Auction* (ca. 1981) and *Working Art* (1985). Indeed, the large number of hand-drawn graphics that make up the collection strongly conveys a DIY aesthetic and everyone-as-artist ethos. As one activist told Sue, "We didn't have a voice in the media, or a radio station, or anything else, so the only way we could let people know what was going on was to put a poster up."

Contrasting with these local, often-utilitarian posters is a small set of international prints. Many are well-designed and make a wider use of symbolism, typography, and more sophisticated print technologies like offset or silkscreen. Kotare allies, in solidarity with international campaigns, added such posters as the Swedish

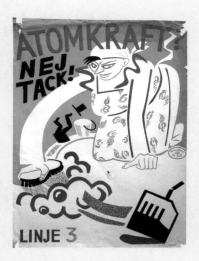

Atomkraft? Nej Tack!, 1979, Gittan Jönsson (Sweden).

anti-nuclear *Atomkraft? Nej Tack!* (Nuclear Power? No Thanks!) to the collection, enabling local workshops to discuss issues and events on a global scale.

Kotare continues to be a repository for posters made by activists and political organizers. However in the digital age, a real challenge is capturing the born-digital posters circulated via social media. Yet new stories and new provenance continue to work their way in and out of the archive—due in part to such means. A year ago, as I browsed the internet from my home in Christchurch, I came across a photograph of the People's Library at Occupy NYC. There, hanging at the main entrance, was my poster for Kotare Trust. It reminded me that the revolutionary continuum does not end in the archive. It is simply a new beginning. ⑤

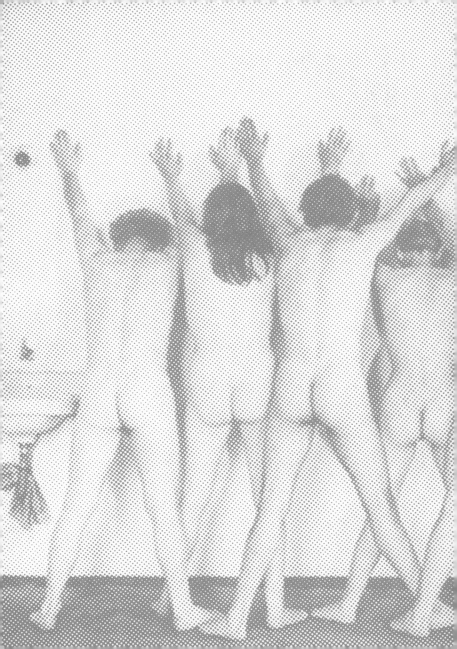

KOMMUNE I

Michael McCanne

1.

On the evening of April 5, 1967, West German police kicked down the door of Uwe Johnson's apartment, a prominent novelist. Inside they arrested eleven members of Kommune 1, a radical student group, who had taken up residence in the apartment during the novelist's absence and were in the process of measuring and mixing "unknown chemicals" into plastic bags. The American vice president Hubert Humphrey, was to arrive in Berlin the following day and give a speech at the Schöneberg council house, nine blocks from the apartment. Police claimed they had foiled an assassination attempt, and the German press described an international conspiracy by a "Horror Commune" of young radicals. Rumors ran wild. Chinese agents in East Berlin had supplied the explosives. The Maoist students were following orders from Peking.

The police arrested a few more students in the following days, and all were charged with conspiracy to commit murder. The unknown chemicals, however, turned out to be ingredients for buttermilk pudding, which the communards planned to throw at the vice president and the whole affair became known as the "Pudding Plot." The initial charges were reduced to plotting a criminal assault and eventually all the students were acquitted. They denied direct political motivations for their actions but others drew it for them. Ulrike Meinhof, then a columnist for the left-wing journal *Konkrete*, wrote, "It is considered rude to pelt politicians with pudding and cream cheese but quite acceptable to host politicians who are having villages eradicated and cities bombed."

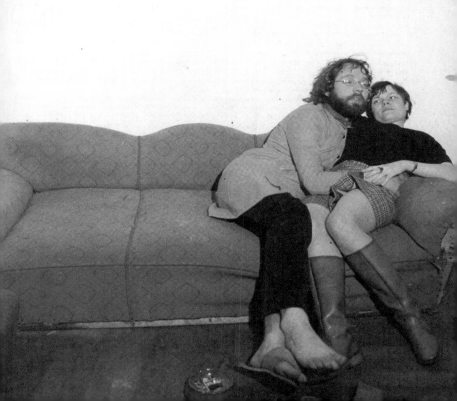

This page: Fritz Teufel in Kommune 1, photograph by Werner Kohn; previous page spread: Kommune 1 in 1967, photographed by Thomas Hesterberg.

Avantgarde ist unerwünscht!

(Flugblatt der SITUATIONISTISCHEN INTERNATIONALE)

1. Die heutige Avantgarde, die nicht geltende Mystifikationen wiederholt, ist gesellschaftlich unterdrückt. Die Bewegung, die von der Gesellschaft erwünscht ist, kann von ihr aufgekauft werden: das ist die Pseudoavantgarde.

2. Wer neue Werte schafft, dem erscheint das heutige Leben als Illusion und Fragment. Wenn die Avantgarde die Frage nach der Bedeutung des Lebens stellt, aber unzufrieden damit, ihre Folgerungen verwirklichen will, sieht sie sich von allen Möglichkeiten abgeschnitten und von der Gesellschaft abgekapselt.

3. Die ästhetischen Abfälle der Avantgarde wie Bilder, Filme, Gedichte usw. sind bereits erwünscht und wirkungslos; unerwünscht ist das Programm der völligen Neugestaltung der Lebensbedingungen, das die Gesellschaft in ihren Grundlagen verändert.

4. Nachdem man die Produkte der Avantgarde ästhetisch neutralisiert auf den Markt gebracht hat, will man nun ihre Forderungen, die nach wie vor auf eine Verwirklichung im gesamten Bereich des Lebens abzielen, aufteilen, zerreden und auf tote Gleise abschieben. Im Namen der früheren und jetzigen Avantgarde und aller vereinzelten, unzufriedenen Künstler protestieren wir gegen diese kulturelle Leichenfledderei und rufen alle schöpferischen Kräfte zum Boykott solcher Diskussionen auf.

5. Die moderne Kultur ist substanzlos, sie besitzt keinerlei Kraft, die sich den Beschlüssen der Avantgarde wirklich widersetzen könnte.

6. Wir, die neue Werte schaffen, werden von den Hütern der Kultur nicht mehr lauthals bekämpft, sondern auf spezialisierte Bereiche festgelegt, und unsere Forderungen werden lächerlich gemacht.

7. Darin sollen die Künstler die Rolle der früheren Hofnarren übernehmen, von der Gesellschaft bezahlt, ihr eine bestimmte kulturelle Freiheit vorzuspiegeln.

8. Der gesellschaftliche Dünkel will der Avantgarde ein Niveau vorschreiben, das sie nicht verlassen darf, wenn sie gesellschaftsfähig bleiben will.

9. Die Existenz des Künstlers ist das Ferment zur Metamorphose unserer absterbenden europäischen Kultur, einem Prozeß, der nicht aufzuhalten, sondern zu beschleunigen ist.

10. Die europäische Kultur ist ein krankes, altes, schwangeres Weib, das sterben wird. Sollen wir den absolut aussichtslosen Versuch unternehmen, die Mutter zu retten - oder soll das Kind leben? - Die Restaurativen wollen noch die Mutter retten - und töten damit auch das Kind. D e Avantgarde hat sich entschieden: die Mutter muß sterben, damit das Kind leben kann!

11. Die Avantgarde von gestern ist comme il faut. Die künstlerische Linksfront ist heute ein Wahrheitsproblem: „Eine Wahrheit wird nur 10 Jahre alt". (Ibsen)

12. Künstler und Intellektuelle: unterstützt die situationistische Bewegung, denn sie jagt keinen Utopien nach, sondern ist die einzige Bewegung, die den gegenwärtigen kulturellen Zustand aufhebt.

13. Die Aufgabe der Avantgarde besteht einzig und allein darin, ihre Anerkennung zu erzwingen, ehe ihre Disziplin und ihr Programm verwässert worden sind. Das ist es, was die Situationistische Internationale zu tun gedenkt.

Herausgegeben von der GRUPPE SPUR als

DEUTSCHE SEKTION

der SITUATIONISTISCHEN INTERNATIONALE

Sturm · Prem · Fischer · Kunzelmann · Zimmer

der SKANDINAVISCHEN SEKTION

Steffan Larsson · Asger Jorn · Jörgen Nash · Katja Lindell

und der BELGISCHEN SEKTION

Maurice Wyckaert

Flier produced by SPUR, 1961.

München, Januar 1961

2.

Sometimes small groups act at just the right moment to channel a great rush of history or bring together disparate but important historical actors, and Kommune 1, or K1, seems that way. Their brief experiment in provocation and communized living merged art practices and the political, the performative, and the actual. What started as pure theater ended in spectacular reality—but in those early years, before the climax of 1968—the future leaders of the New Left and the German Autumn alike cut their teeth on Dadaist agitation.

In the years after the Second World War, Western European countries made massive gains in living standards and economic growth. West Germany bounced back from war and division to lead the continent in industrial production and GDP—what is called the *Wirtschaftswunder* or economic miracle. During this growth, social democracy and moderation served as buffers against the extremes of right and left wing politics. But along with these liberal economic policies came a stifling social conservatism, re-entrenching values of work, church, and family. The 1968 generation grew up with this odd paradox of economic prosperity and social glaciation, always haunted by the bitter aftertaste of National Socialism.

Out of this seemingly static landscape Kommune 1 appeared to emerge from nowhere—a new and terrifying phenomenon. But it was, as political projects always are, part of a continuity of actions, ideas, and experiments. Dieter Kunzelmann traversed this continuity, starting with the K1's artistic origins and continuing with its connection to terrorism. At the time of the Pudding Plot trial he was twenty-eight, older than most of his codefendants, and his

Vittorio Veneto - Giardini Pubblici e Municipio

bald crown and shaggy features distinguished him from the band of rather clean-looking students. He was seasoned in aesthetic political action, having begun nearly a decade before down the path to radicalism. After dropping out of high school, he fell in with the Munich-based, German wing of the Situationist International, called the SPUR Group, which edited a journal of the same name. They asked him to write for the journal, and Kunzelmann's propensity for confrontation with authority led to the print run of an entire issue being seized as obscene. Guy Debord supported SPUR during the obscenity trial but expelled them from the International a year later, accusing them of "a systematic misunderstanding of Situationist theses." Around the same time, Kunzelmann also broke with the SPUR to form the more action, and actionist, oriented *Subversive Aktion*.

Sensing some potential, the editorial group behind *Subversive Aktion* moved en masse to West Berlin. The city was still very empty from war and division, and its special status as an occupied zone meant that West German men who lived there were exempt from compulsory military service. This brought young West Germans to the city in droves, many of whom enrolled in the Freie Universitat and started to question the world they were inheriting,

a world deeply scarred by the legacy of totalitarianism and advances in technology and bureaucracy. The U.S. was already involved in Vietnam and using West German airbases to ferry soldiers and munitions to support the South Vietnamese regime, and opposition to the war was growing amongst the students. In this milieu, Kunzelmann befriended Rudi Dutschke, a young East German refugee studying at the Freie Universitat. One night after attending a lecture by Ernst Bloch, the pair watched the new Louis Malle film *Viva Maria!* and were so taken by it that they went back to see the film every night that week. With other students from the Freie Universitat and future K1 leader Dorothea Ridder, they formed a group called Viva Maria.

In 1965, Dutschke joined the Sozialistische Deutsche Studentenbund (SDS, German Socialist Student Union), the most influential student organization in West Germany. Kunzelmann joined as well and they created a commune/working group with several other students to formulate how to make new living situations. They discussed breaking with authoritarian family structures and monogamous relationships as a necessary precondition for revolutionary action. They talked about setting up their own

Nr. 1 29.2.68 *linkeck*

50 Pfennig in Berlin
1.— DM in west deutsch land

Daß Du Beatmusik magst und
gerne tanzt und am liebsten
vögelst
finde ich gut

Paß auf daß Du auch
später Beatmusik hören
und tanzen und
vögeln kannst denn
es gibt Leute die
etwas dagegen haben daß
Du gerne Beatmusik hörst und tanzt und vögelst

Beim Zivilschutzkorps gibt es nur Drill und Befehle
und der Blockwart
wird Dir das Vögeln schon verleiden

Also paß auf
und tu verdammt noch mal etwas
und wenn Du auf Eiern schneefst
und den Verkehr blockierst
ist das schon besser
als gar nichts

Wenn der Staat Dir
Tanzen und Vögeln verleiden will
mach den Staat kaputt

B·Z· Vergast die Kommune!

Die größte Zeitung Berlins

Dreigeteilt – niemals!

Einem nackten Mann kann man nicht in die Tasche fassen: Klaus Schütz, der Staatsmann aus den Rentners Wunderland konnte sich deshalb beim CIA-Boss Helms Ratschläge für die Bewältigung der verfahrenen innenpolitischen Situation holen, nicht aber dringend benötigte Aufträge für die hiesige Wirtschaft, deren einzelne Sektoren 1967 zum Teil bis zu 31 ½ % gegenüber der BRD zurückgefallen sind, ist durch unser Weltpolizist selber bankrott.

Den faschistoiden Machtpolitikern im Rathaus kommt deshalb die studentische "Sturm im Wasserglas"nicht ganz ungelegen; Schütz, der ratlose linke Renegat, drohte, der Regierende Bürgermeister in spe, Neubauer, ließ den 2. Ersatz der "Bürgerkriegsarmee" über den Kopf des Strohmanns Noch hinweg mobilisieren. Er hätte die Machtkonfrontation am Wochenende brauchen können; 1000 blutige Studentenköpfe hätten die berliner Reaktion über 28 000 weniger Arbeitsplätze in der Industrie hinweggetäuscht. ... hatten kein Glück, und post ...

festum sammelte sich wutschnaubend ein Fähnlein von 100 Aufrechten nur, die mit markigen Sprüchen unterm Banner der Monopole hinzeichten ; Noch sah keinen Grund zum Einschreiten, hatte diese Demonstration ist doch "spontan" gebildet.
Ihr Spruch vom "inneren Feind" der sich über die Mauer oder nach Westdeutschland scheren solle, ging flugs darauf unter im Unisono der antikommunistischen Einheitsfront.
Und darauf setzen unsere Politmanager, vor allem unser unfehlbarer Zwilling, Neubauer-Prylljzeigte sich vor Jahre ...

die Ohnmacht der blinden Reaktion im Anblick des abgekarteten Baus der Mau-

er, so hat sie jetzt ihre Chance in der Mobilisation gegen die Unruhestifter, den subversiven Agenten des "Äusseren Feindes", der letzten Endes schuld ist an ökonomischen Niedergang der Stadt, zieht er den "Ruf und Ansehen in den Schutz".
Den entsprechen die Ergebnisse der ifas, die ein stetes Steigen der Ungunst des Senats und der SPD in der Bevölkerung feststellen, zuletzt sind 80% gegen die "weiche Welle". Sie, die leidgeprüfte Bevölkerung, wünscht den starken Mann, der die "bewährte Ordnung" wieder herstellt, und Neubauer, Springers heimlicher Held, ist hier ...

und hergerissen zwischen diesem Flebisazit und der liberalen Maske, die nach aussen aufrechterhalten bleiben muss.

Und so verfällt er und seine Kumpane auf den alten stalinistischen Trick "soweit abkömmlich" wird die "Mehrschar der Lumpenbürokratie" freigestellt für eine machtvolle Gegendemonstration. Und mit sich überschlagender Stimme rufen die Springergezetten Arbeiter, Mittelstand und Kapitalisten auf, die Arbeit einzustellen und zu erscheinen, um ihren Willen zu bekunden, auf dass sich das Debakel vom 17. Juni 1967 nicht wiederholde.
Die Demonstration der Lumpenbürokraten aber muß notwendig versagen: der in die Sphäre isolierter Meinung abgeglittene funktionslose Antikommunismus vermag sich höchstens hie und da noch an einer Zeitungsnotiz zu einer schwachen Erektion aufzupuschen.

commune, and Kunzelmann even wrote a treatise on the subject: "Notes for Establishing Revolutionary Communes in the Metropole."

When Ridder and Kunzelmann sought to put these discussions into practice, Dutschke balked and they invited other people instead. Rainier Langhans, a law student, joined the project, as did Dagrun and Ulrich Enzensberger (ex-wife and brother of prominent novelist Hans Magnus Enzensberger), who helped secure the commune's place in Uwe Johnson's apartment. Once settled, the communards pushed to break with bourgeois norms. As with most of the New Left, they fell heavily under the theories of the Frankfurt School, especially the anti-authoritarian bent of Herbert Marcuse, but were also enthralled with Wilhelm Reich's theories

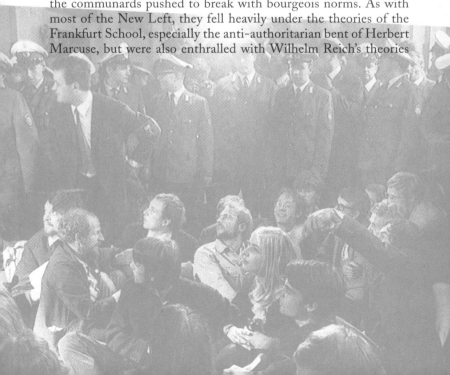

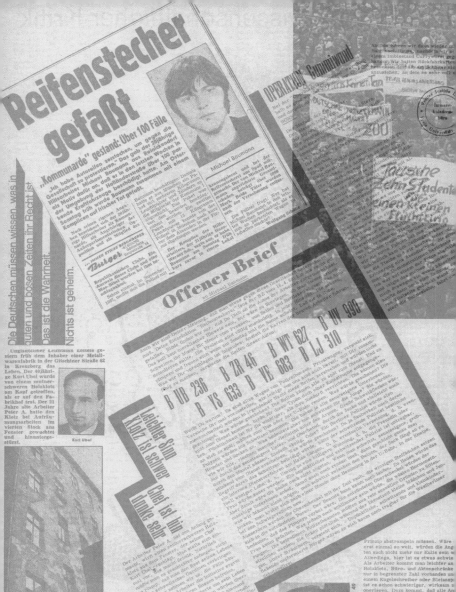

Reifenstecher gefaßt

„Kommunarde" gestand: Über 100 Fälle

Die Deutschen müssen wissen, was in ihnen gut und bösen Zeiten ihr Recht ist. Das ist die Wahrheit. Nichts ist geheim.

Michael Baumann

Ungtiuntioner Leichnism konseie gestern früh dem Inhaber einer Metallwarenfabrik in der Gitschiner Straße 62 in Kreuzberg das Leben. Der 58jährige Kurt Übel wurde von einem zentnerschweren Holzklotz am Kopf getroffen, als er auf den Fabrikhof trat. Der 21 Jahre alte Arbeiter Peter A. hatte den Klotz bei Aufräumungsarbeiten im vierten Stock aus Fenster gewuchtet und hinuntergestürzt.

Kort Übel

Offener Brief

an Michael Baumann

Leichter Sinn — Klotz ist schwer
Übel ist hin danke sehr

B UB 236 B ZR 46 B WT 627 B UV 990
B TS 63 B VE 663 B LJ 310

Walter Sickert 49

Volksschüler Polizist

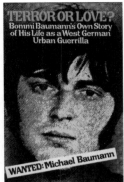

of sexuality and authority. Their hair got longer and they advocated a communism of goods and free love—all doors were removed and the communards all slept in one large room. This intensity of communalism—pushed by Kunzelmann, Langhans, and the newly arrived Fritz Teufel, the patriarchs of the commune—brought more members and attention to the group but also drove several away. Tales of orgies were surely exaggerated for and by the tabloid media, but monogamy was definitely frowned on, especially when a woman did not want to sleep with a man in the commune. This led to an unfortunately common dynamic where most women (with the exception of the founding members Dagrun Enzensberger, Dagmar Seehuber, and Dorothea Ridder) were reduced to the role of groupies and girlfriends, or pushed out for not being sufficiently "sexually liberated." Some started other communes around the city. A girlfriend of Rainer Langhans, Antje Krüger, left him and K1 to form another commune (and publication) called *Linkeck*, less focused on sex than an equal division of labor and the abolition of property. Michael "Bommi" Baumann joined K1 after befriending

them in SDS, but also moved on to other groups. The future leaders of the Red Army Faction, Andreas Baader and Gudrun Ensslin, often hung around the commune. Ensslin was then an earnest student activist and Baader a petty thief with a taste for the bohemian lifestyle.

3.

As the U.S. war in Vietnam expanded, the student movement coalesced into the Außerparlamentarische Opposition (extra-parliamentary opposition), a broad amalgamation of radical groups led by the SDS. Kommune 1 sought to position themselves within this protest movement as leaders and provocateurs. Their strategy differed however from the SDS with its rigidly Marxist analysis and its self-serious conferences and demonstrations, and the divide was so great that SDS expelled the communards in 1967. Instead K1 elaborated a strategy combining the aesthetic provocations of Dada, the Viennese Actionists, and the Situationists with models for guerilla warfare coming out of the Third World. Teufel called this form the Spassguerilla or fun guerilla, a play on the *stadt-guerilla* or urban guerilla. The Spassguerilla's main weapons were satire and chaotic or unintelligible actions. They suggested "mill-in" protests, a proto-flash mob, to demand more vacation time for the police. They used imagery of the Third Reich and the Watts Riots in their fliers and made signs that cribbed the phrases of law-abiding citizens: "Go to the East!" and "With Hitler, this wouldn't have happened!"

With its various pranks K1 hoped to show that "the paragons of our society are buffoons." The Pudding Plot, though never realized, was aimed at just that and was inspired by the Dutch group

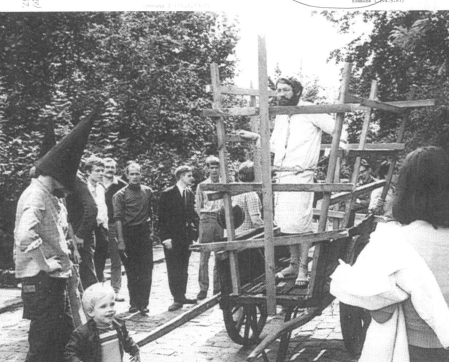

Wann brennen die Berliner Kaufhäuser?

Bisher krepierten die Amis in Vietnam für Berlin. Uns gefiel es nicht, dass diese armen Schweine für Cocacolablut im vietnamesischen Dschungel verspritzen mussten. Deshalb trotteten wir anfangs mit Schildern durch leere Strassen, warfen ab und zu Tier ans Amerikahaus und zuletzt hätten wir gern USA in Pudding sterben sehen. Den Schah pissen wir vielleicht an, wenn wir das Hilton stürmen, erfährt er auch einmal, wie wohltuend eine Kastration ist, falls überhaupt noch was drankommt ... es gibt da nur böse Gerüchte.

Ob leere Vorbuden bewarfen, Repräsentanten lächerlich gemacht wurden — die Bevölkerung konnte immer nur Stellung nehmen durch die spannenden Dschungel Fressberichte. Unsere belgischen Freunde haben endlich den Dreh heraus, die Bevölkerung am lustigen Treiben in Vietnam wirklich zu beteiligen: sie zünden ein Kaufhaus an, d reihundert saturierte Bürger beenden ihr aufregendes Leben und Brüssel wird Hanoi. Keiner von uns braucht mehr Tränen über das arme vietnamesische Volk bei der Frühstückszeitung zu vergiessen. Ab heute geht er in die Konfektionsabteilung von KaDeWe, Hertie, Woolworth, Bilka oder Neckermann und zündet sich diskret eine Zigarette in der Ankleidekabine an. Dabei ist nicht unbedingt erforderlich, dass das betreffende Kaufhaus eine Werbekampagne für amerikanische Produkte gestartet hat, denn wer glaubt noch an das "made in Germany"?

Wenn es irgendwo brennt in der nächsten Zeit, wenn irgendwo eine Kaserne in die Luft geht, wenn irgendwo in einem Stadion die Tribüne einstürzt, seid bitte nicht überrascht. Genauso wenig wie beim Überschreiten der Demarkationslinie durch die Amis, der Bombardierung des Stadtzentrums von Hanoi, dem Einmarsch der Marines nach China.

Brüssel hat uns die einzige Antwort darauf gegeben:

 burn, ware-house, burn!

 Kommune I (24.5.67)

Provo who had thrown smoke bombs at the wedding of Princess Beatrix in Amsterdam two years earlier, causing the police to run amok and attack the crowds attending the protests. Though they were prevented from realizing their attack on Humphrey, they learned instead about creating a media frenzy. It was an instructive lesson and they remained cognizant of the media's potential to further their own goals in a time when the potential of the mass media was still largely unmeasured. They spent every morning sifting through the numerous daily newspapers, looking for references to them or their friends. In a sign that they were already aware of their future contextual place in history, they kept an archive of all their clippings. Eventually they culled those writings and clippings into a book called *Klau Mich* (Steal Me), published in 1968, two years before the Yippies wrote *Steal This Book*. During the Pudding Plot trial they reenacted the building and testing of smoke bombs for the cameras of a West

German news agency. As for their actions, they planned everything from street provocations to their own trials. Kunzelmann envisioned very early on provoking huge trials and using them to their own ends. The spontaneous outbursts in the proceedings would be carefully scripted and thought out ahead of time, designed to maximize attention and media coverage.

In May of 1967 a large department store burned down in Brussels, killing 253 people. The communards drafted several sensationalist fliers (typed and numbered in large, childish numbers) titled *New Type of Demonstration Tested in Brussels* and *When Will Berlin Department Stores Burn?*. The fliers claimed that Belgian groups had set the fire to protest the American war in Vietnam.

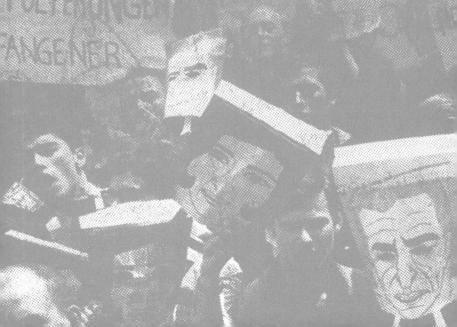

"Our Belgian friends have finally caught on to how they can really draw the public into the lustful activities of Vietnam. They set fire to a department store, 300 satiated citizens end their fascinating lives and Brussels becomes Hanoi." K1 signed and distributed the fliers on the FU campus. The tabloid press quickly picked up on the story, perhaps tipped off by the communards themselves, and howled for blood. A few weeks later, on June 2, the Shah of Iran visited the Deutsche Opera House in Berlin (a few blocks from K1's residence), and demonstrators filled the streets around the building, hurling epithets and bags filled with flour. The West German police attacked mercilessly, scattering the protestors to the side streets of Charlottenberg. In the car park of a neighboring apartment complex, for reasons still

unclear, a plainclothes policeman pulled his service revolver and shot twenty-sex-year-old Benno Ohnesorg in the head. He died later at the hospital, marking a dramatic turn in West German social struggle.

In another part of the neighborhood, Fritz Teufel was arrested on charges of inciting riot and hurling stones. He was also charged along with Rainer Langhans with inciting life-threatening

activity with the arson fliers. Their trial was postponed, and they were released on remand. In August, Teufel was wheeled in a wooden cage to the Moabit prison's entrance, where he demanded to be let back in. The authorities refused, but when K1 staged a sit-in later, he was arrested and put back into detention. Then demonstrations to "Drive the Devil out of Moabit"—*teufel* being the German word for devil—took place regularly. On the occasion of the death of the politician Paul Löbe, K1 staged an elaborate mock funeral outside the official ceremony, carrying a black velvet coffin emblazoned with the word SENAT towards the state building where the real funeral was taking place. When the police tried to rush the pallbearers, Dieter Kunzelmann burst out of the coffin in pajamas and started throwing pamphlets in the air, pamphlets that demanded Teufel's release and listed "corpses" in the Berlin Senate they would like to bury along with Löbe.

When the arson fliers trial resumed in 1968 it degenerated into a bizarre spectacle. The West German judiciary, still under the shadow of its collaboration with the Third Reich and trying to maintain a deliberative and objective appearance, had trouble dealing with the K1 defendants' disruptive and irreverent attitudes. They wore outrageous outfits—Langhans often in some form of drag with pearls contrasting a Mao pin. They interrupted the proceedings, addressed the audience as if they were in a play or a public forum. When the prosecuting attorney asked that they be given a psychiatric evaluation, they agreed on the condition that the entire court undergo an evaluation as well. The judges for their part tried to maintain order and get at the true intentions of the arson fliers. They convened a panel of literary authorities, including Günter Grass, to determine whether the fliers were literature or not.

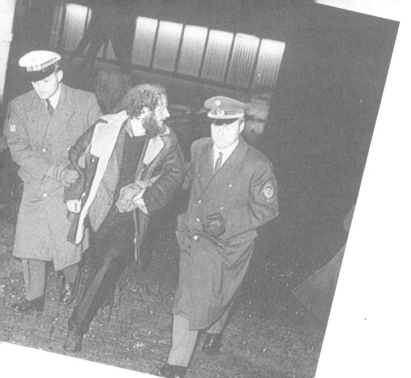

Invoking Kant, Schiller, and Sartre, the panel found that the fliers were works of surrealist art, not incitement, and Langhans and Teufel were found innocent and released on March 22, 1968.

After the trial, Gudrun Ensslin and Andreas Baader arrived at the commune's apartment and asked if any of them wanted to go to Frankfurt to "play with fire" for real. The communards declined, and Ensslin and Baader went without them. They set fire to several department stores at night, harming no one but causing significant damage. Ensslin and Baader were arrested and faced their own arson trial, deploying many of the same provocative strategies pioneered by K1. A week after the fire, a right-wing sympathizer shot Rudi Dutschke in the streets, nearly killing him. The students held the Springer media, a right-wing tabloid empire, responsible for inciting the assassination attempt, and attacked its printing facilities and trucks carrying its papers with Molotov cocktails. The

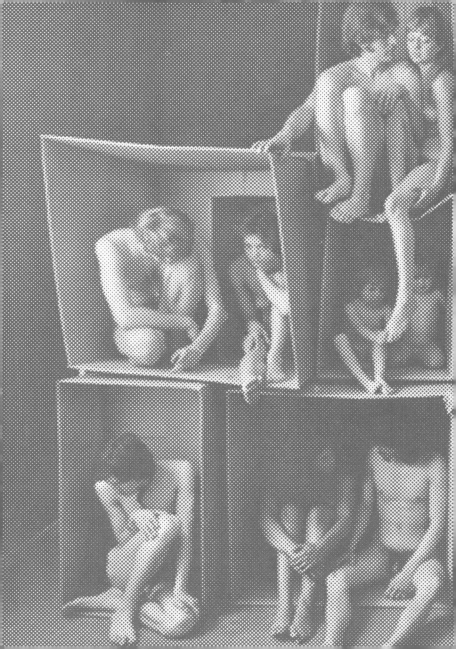

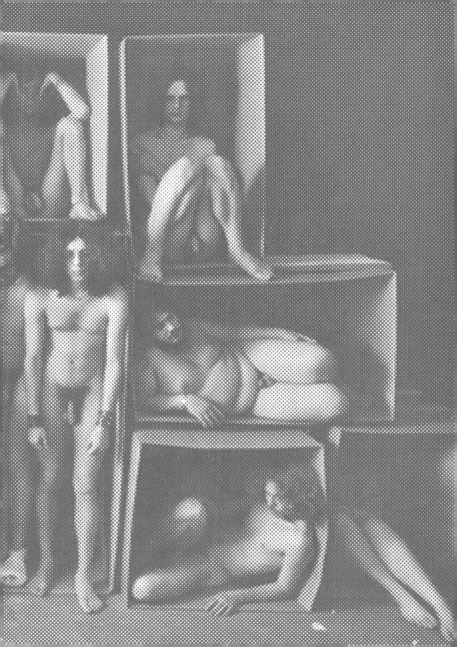

Jedes Urteil wissenschaftlicher Kritik

linkeck 4

ist mir willkommen

following month the country was convulsed by extremely violent demonstrations, and parliament passed the Emergency Laws that, for the first time since the Nazis, established a legal framework to curtail civil rights and declare a state of exception.

Kommune 1 fractured amidst the confrontational politics unfolding around them, some of which they had helped catalyze. Their provocative rhetoric had been met and exceeded by the most militant wings of the extra-parliamentary opposition. The disintegration of the student movement and commensurate turn toward armed struggle diminished the attention the media paid to purely spectacular antics. Fritz Teufel left (or was possibly expelled), and Kommune 1 moved into an abandoned factory and retreated inward, focusing on self-discovery through drugs and interpersonal practices. Langhans met the fashion model Uschi Obermaier at a rock festival and convinced her to move into the commune with him—a juicy morsel for the tabloid press, which routinely photographed the couple. Kunzelmann became addicted to heroin and grew more disillusioned with the K1's turn toward the personal sphere. He was expelled from the group and went to Jordan to train in guerilla warfare at a Fatah camp.

Langhans, the last of the K1 patriarchs, took sole leadership of the commune, letting the politics of K1's previous days slip away in favor of fashion photos, music, and drugs. Celebrities like Jimi Hendrix made appearances at the commune, and reporters and television crews paid for interviews and exclusives. He invited a group of leather-clad youth (known as Rockers) to take over the ground floor of the factory. When Uschi grew fed up with the living arrangements and sharing her increasingly lucrative modeling fees with the communards, she moved back to Munich. Langhans decided to go with her and dissolved the commune in 1969. When the Rockers found out, they promptly went upstairs and trashed the place, beating up and driving out the remaining members.

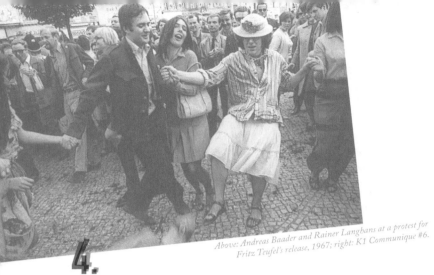

Above: Andreas Baader and Rainer Langhans at a protest for Fritz Teufel's release, 1967; right: K1 Communique #6.

4.

Kommune 1 were largely victims of their own Icarian success. They were extremely savvy at manipulating the media and the legal system into reacting the way they wanted, and for a small group they were able to bring huge amounts of attention to new political ideas in West Germany. But they tried to use spectacle against spectacle and were eventually subsumed by the society they were trying to overturn. Their protests were so focused on what was essentially aestheticized action that they lacked any plan for actually undoing the world they were against. In the end their need to stay in the limelight, to produce spectacular situations, outpaced the possibility of real political action, and once they divorced the performative from the political, they were left with an empty aesthetic. Those communards who wanted to continue the struggle looked for new, more powerful methods without losing their propensity for the spectacular.

In a 1970 interview, Fritz Teufel declared famously "Teufel the Clown is dead" and so too was the Spassguerilla, supplanted in the end by the urban guerilla, which would dominate West German politics for the next decade and largely be led by former K1 members or associates. Ensslin and Baader jumped bail on their arson charge and began their meteoric journey to Stammheim as the first wave of the Red Army Faction—joined along the way by journalist

Neue Demonstrationsformen in Brüssel erstmals erprobt

In einem Großhappening stellten Vietnamdemonstranten für einen halben Tag kriegsähnliche Zustände in der Brüsseler Innenstadt her.

Diese seit Jahren größte Brandkatastrophe Belgiens hatte ein Vorspiel. Zur Zeit des Brandes fand in dem großen Kaufhaus A l'Innovation (Zur Erneuerung) gerade eine Ausstellung amerikanischer Waren statt, die deren Absatz heben sollte. Dies nahmen eine Gruppe Antivietnamdemonstranten zum Anlaß, ihren Protesten gegen die amerikanische Vietnampolitik Nachdruck zu verleihen. Ich sprach mit dem Mitglied der pro-chinesischen Gruppe "Aktion für Frieden und Völkerfreundschaft" Maurice L. (21): "Wir vermochten uns bisher mit unseren Protesten gegen die amerikanische Vietnampolitik nicht durchzusetzen, da die hiesige Presse durch ihre Berichterstattung systematisch den Menschen hier den Eindruck vermittelt, daß ein Krieg dort unten notwendig und zudem gar nicht so schlimm sei. Wir kamen daher auf diese Form eines Happenings, die die Schwierigkeit, sich die Zustände beispielsweise in Hanoi während eines amerikanischen Bombenangriffs vorzustellen, beheben sollte."
Der Verlauf des Happenings spricht für eine sorgfältige Planung: Tage zuvor fanden kleinere Demonstrationen alten Musters vor dem Kaufhaus mit Plakaten und Sprechchören statt und in dem Kaufhaus wurden Knallkörper zwischen den Verkaufstischen gezündet. Das Personal wurde so an derartige Geräusche und Zwischenfälle gewöhnt. Die Bedeutung dieser Vorbereitungen zeigte sich dann bei Ausbruch des Feuers, als das Personal zunächst weder auf die Explosionen, noch auf Schreie und Alarmklingeln reagierte. Maurice L. zu dem Brand: "Sie werden verstehen, daß ich keine weiteren Angaben über die Auslösung des Brandes machen möchte, weil sie auf unsere Spur führen könnte." Das Feuer griff sehr schnell auf die übrigen Stockwerke über und verbreitete sich dann noch in den anliegenden Kaufhäusern und Geschäften, da die umgebenden Straßen für die anrückende Feuerwehr zu eng waren. Der Effekt, den die Gruppe erreichen wollte, dürfte wohl ihren Erwartungen voll entsprochen haben. Es dürften im Ganzen etwa 4000 Käufer und Angestellte in die Katastrophe verwickelt sein. Das Kaufhaus glich einem Flammen- und Rauchmeer; unter den Menschen brach eine Panik aus, bei der viele zertrampelt wurden; einige fielen wie brennende Fackeln aus den Fenstern; andere sprangen kopflos auf die Straße und schlugen zerschmettert auf; Augenzeugen berichteten: "Es war ein Bild der Apokalypse"; viele erstickten schreiend. Das Riesenaufgebot an Feuerwehr und Polizei war wegen der Neugierigen und der ungünstigen Raumverhältnisse außerordentlich behindert - ihre Fahrzeuge waren mehrmals in Gefahr, in Brand zu geraten.
Maurice L.: "In der vorigen Woche hatten wir eine anonyme Bombendrohung an das Kaufhaus durchgegeben, um festzustellen, welche Maßnahmen die Polizei und welche Sicherungsmaßnahmen das Kaufhaus ergreifen." - Da zu erwarten war, daß die Betroffenen die Ursache des Brandes mißdeuten würden, hatte die Gruppe nach Maurice L. schon Tage zuvor und vor allem am Tage des Großhappenings Flugblätter verteilt, die auf die Zustände in Vietnam hinwiesen und empfahlen, die Ausstellung im "Kaufhaus A l'Innovation "hochgehen" zu lassen. Nach sieben Stunden erst war das Großfeuer unter Kontrolle - der Schaden beträgt nach vorsichtigen Schätzungen ca. 180 Mill. DM.
Über die Ursachen des Brandes wurden von der Polizei bisher noch keine genauen Angaben gemacht. Obwohl alle Anzeichen für dieses Großhappening sprechen, wie es Maurice L. schilderte, wagen Polizei und Öffentlichkeit bisher nicht, die Antivietnamdemonstranten offen zu beschuldigen, da dies einem Eingeständnis einer erfolgten weitgehenden Radikalisierung der Vietnamgegner gleichkäme. Es könnte zudem bewirken, daß andere Gruppen in anderen Städten wegen der Durchschlagskraft dieses Großhappenings nicht nur in Belgien zu ähnlichen Aktionen ermuntert würden. Und selbst wenn sich durch eine Unvorsichtigkeit der Demonstranten die Urheberschaft dieser obengenannten Gruppe eindeutig herausstellen würde, dürfte dies nicht dazu führen, daß die Polizei das Ergebnis veröffentlicht, da der obige Effekt der Ermunterung anderer Gruppen eine solche Veröffentlichung inopportun erscheinen läßt. KOMMUNE I (24.5.67)

Ulrike Meinhof and Horst Mahler, the lawyer that had defended K1 during their trials. Teufel moved to Munich were he founded the nebulous Tupamaros Munich—an urban terrorist group modeled on the Uruguayan group of the same name. Kunzelmann and Bommi Baumann started a related project in West Berlin. The two groups would eventually coalesce into the June Second Movement and free another former K1 communard from prison by kidnapping a politician and exchanging him for political prisoners. As a nod to their playful origins, the June Second members passed out chocolates when they were robbing banks.

In 1969 Kunzelmann and other West Berlin Tupamaros planned to bomb a synagogue on the anniversary of Kristallnacht to draw attention to the plight of Palestinians. The device didn't go off but the attempt cast an ugly pall on the movement. Perhaps Kunzelmann's desire to shock and outrage finally overrode his sense of reality, or perhaps his anti-Israel stance simply transformed into anti-Semitism. Either way, he was arrested the following year and sentenced to prison for other fire-bombings and robberies. When he got out, Kunzelmann ran for office on the Alternative List. Teufel was arrested as well and spent most of the 1970s in prison. When he was released he got involved in the budding squatting and environmental movements of the 1980s. While participating in a discussion on television he shot the then finance minister with a water pistol, suggesting Teufel the clown was not completely dead. Dorothea Ridder went on to practice psychology, and Langhans continues to live out his counter-cultural celebrity. In 2007 a mainstream film dramatized his relationship with Uschi Obermaier. Ever the opportunist, Langhans made his own documentary alongside it, historicizing himself and Kommune 1 into the pre-history of the present. **S**

A scene from the "Battle of Tegeler Weg," Berlin 1968; right: an example of how Uschi Obermaier and the later Kommune 1 were represented in the media.

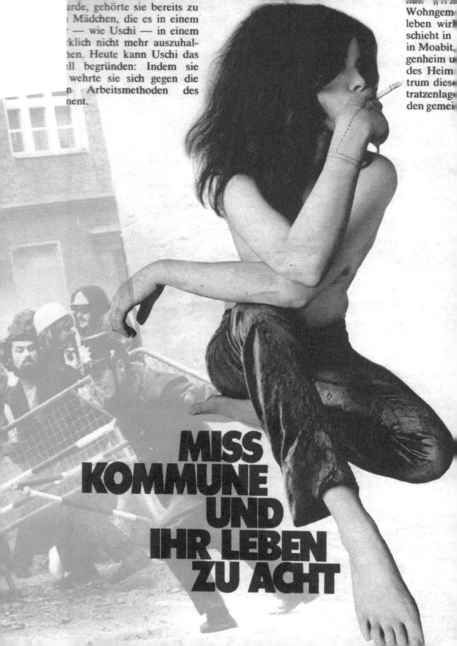

urde, gehörte sie bereits zu
n Mädchen, die es in einem
— wie Uschi — in einem
rklich nicht mehr auszuhal-
hen. Heute kann Uschi das
ell begründen: Indem sie
wehrte sie sich gegen die
n Arbeitsmethoden des
nent.

Wohngem
leben wir
schieht in
in Moabit,
genheim u
des Heim
trum dies
tratzenlag
den gemei

MISS KOMMUNE UND IHR LEBEN ZU ACHT

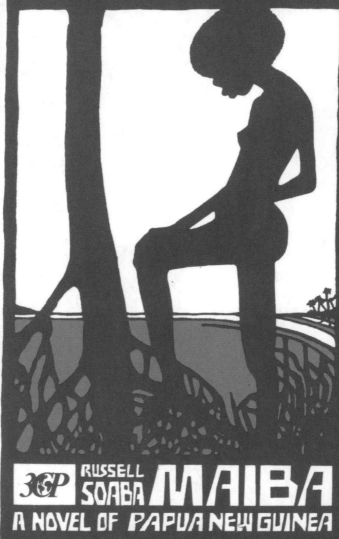

RUSSELL SOABA **MAIBA**

A NOVEL OF PAPUA NEW GUINEA

ILLUSTRATING THE 3RD WORLD

Book cover designer Max Karl Winkler interviewed by Josh MacPhee

When and how did you meet Don Herdeck, the founder and publisher of Three Continents Press (3CP)?

My introduction to 3CP occurred at a great turning point of my life. I had been living in western Colorado, working first as the in-house artist for a local printer, and for a year or two as a freelance illustrator and designer. The recession of 1983, combined with the failure of my marriage, forced me to look elsewhere for work, and I was hired for a semester at Roanoke College, in southern Virginia, to replace a professor who had taken a sabbatical. Knowing that I'd have to find other work at the end of the semester, I came to Washington, D.C., during my spring break, to make whatever contacts I could with publishers here. It was a hard time for me. I forced myself to make ten cold calls a day, hating every moment of it; and of course I was lucky if one out of those calls gave me an appointment to show my portfolio. My interview with Don Herdeck was the high point of the weeklong break. He explained that 3CP was his private undertaking, established partly to provide texts for his comparative literature courses at Georgetown University. He commissioned

me—on spec—to design a cover for his new book, *Maiba*, one of the
first English-language novels published by a native of Papua New
Guinea [1]. I returned to Roanoke, and spent my evenings for the
next couple of weeks designing and producing comps for that cover.
And, to my delight, Dr. Herdeck accepted one of them.

3CP didn't have the resources to pay well, but designing that
cover encouraged me to move to the D.C. metro area at the end
of the term and embark on a career as a freelance illustrator and
designer. And often when I was hard up for cash, 3CP would have
another book in the hopper. Dr. Herdeck seemed to like my work,
and his editor liked it well enough (though not, I always felt, with
the same enthusiasm as Herdeck's). The editor's name was Norman
Sims. At some point he moved to Singapore, and later I heard that
he had bought 3CP on Don Herdeck's retirement.

Those were hard but exciting times for me. My master's de-
gree was in fine art, drawing and printmaking. I'd had little training
in graphic design, except for employment as a paste-up artist for a

PAPER BOATS
POEMS OF HILARY THAM

3CP AN ORIGINAL FROM THREE CONTINENTS PRESS

5

6

7

8

designer in Austin, Texas, and several years of in-house work for the printer in western Colorado—and a single significant semester of basic book design under Kim Taylor, who had been a writer for *Graphis* magazine in the late 1950s and early 1960s. I moved to Washington in June of 1984, and spent three or four years living just a week or so away from being a street person.

The politics of 3CP seem broadly anticolonial and pro–Third World. Do want to say anything about your politics, in relationship to 3CP or otherwise?

I believe that Don Herdeck and I shared views on colonialism in general, and on the adventuring of great powers in other lands. He had seen enough of it as a Foreign Service officer in Africa, and I had seen a little of it during more than five years that I lived in Mexico. Although I'm a Texan, I'm an unrepentant liberal, as I believe Herdeck was.

The work you did with Three Continents is both diverse and has a very strong personal voice. This feels pretty unique in publishing at the time. How much direction did Herdeck give you? How much creative freedom did you have?

One of the great pleasures of working for Dr. Herdeck was the freedom that he gave me to design covers according to my own inclinations. I've seldom experienced that level of trust from an employer. I believe that he truly liked my work, and felt that it supported his aims. I never felt that he was my "boss"—our relationship was more collegial than that. His usual practice was to describe a book—its narrative curve, its purpose, or both—and then leave me to find a way to make an attractive cover. Sometimes he would give me galleys to read, but other times I was working in a parallel timeframe to the translator. My practice, because it's my nature, was to give him two or three sketches to choose from, before producing a finished design. I had a lot of creative freedom, which I feel resulted from a consonance with Dr. Herdeck's aims.

Can you talk us through the process on a specific design?

Dele's Child, published in 1986, is one of the few books for which I have traces of the development of a cover idea: tucked into the front of the book is the sketch I presented to 3CP for approval. The design began, as usual, with a telephone call from the editor, asking me to come in to discuss a new cover. When I arrived, Dr. Herdeck told me the title of the book and the author's name. For some reason, he couldn't provide galleys, or perhaps he didn't want to wait for me to read the book. He summarized it briefly; as I recall, he told me that the themes of the book were fecundity and cultural legacy, the setting Caribbean. He wrote the title and the author's name, and I returned home to work on a design. On this occasion, I believe, I made only one design, because I knew what I wanted to depict: sun and sea, a person (perhaps child, perhaps woman), and tropical vegetation.

When I presented my design, Dr. Herdeck made some changes. He had miswritten the book's title, so I had designed it as

FLUTES of DEATH

DRISS CHRAIBI

Translated from *Une enquète au pays* by Robin Roosevelt

AN ORIGINAL FROM THREE CONTINENTS PRESS

WORL' DO FOR FRAID

A PLAY IN THREE ACTS

NABIE YAYAH SWARAY

AN ORIGINAL FROM THREE CONTINENTS PRESS

"Dele' Child"; and he wanted my three-color design to be executed in two colors. The result is simply a refined version of that sketch, and is one of my own favorite 3CP covers [21].

Among other favorites are Norman Simms's *Silence and Invisibility* [22], whose acceptance encouraged me to be more experimental with designs than I might otherwise have been; Muhammad al-Maghut's collection of poems, *The Fan of Swords* [3]; Mohammed Dib's *Who Remembers the Sea* [20]; *L'excisée*, by Evelyne Accad [9]; Nabie Yayah Swaray's play, *Worl' Do for Fraid* [12]; and Harold Waters's *Théâtre noir* [17]. All of these, for their own reasons, represented design challenges. Some others, perhaps equally challenging, stand out in my memory as pure fun: Tawfiq al-Hakim's *Fate of a Cockroach* and *The Tree Climber*; Bernard Dadié's *The City Where No One Dies* [28]; Naguib Mahfouz's *Fountain and Tomb* [5,6]; and Hilary Tham's *Paper Boats* [4].

15

16►

Did you think of yourself as a designer or illustrator? Did that change over time?

I've had a very erratic career, teaching college-level art at five or six institutions. I believe that the best artists don't distinguish much between design and illustration, and that's especially true of books and book covers. I do like illustration and making pictures; and whenever possible I've included illustration in my book design. As a designer, that's my great weakness. If I have only type to work with, I get bored—I want to draw. In my view, a book cover is much like a poster: it should serve as an introduction to the book, it should be attractive from some distance, and it should convey its message in the first five seconds.

When I was working in the Publications Division of the National Science Resources Center, which was jointly sponsored by the Smithsonian Institution and the National Academies, I remarked to my supervisor—a writer/editor—that I considered

THE SHIP

JABRA·I·JABRA

TRANSLATED BY ADNAN HAYDAR AND ROGER ALLEN
3CP AN ORIGINAL FROM THREE CONTINENTS PRESS

THÉÂTRE NOIR

Encyclopédie des Pièces écrites en français par des auteurs noirs

ISBN 0-89410-627-9 (cloth)
ISBN 0-89410-628-7 (paper)

THÉÂTRE NOIR

Harold A. Waters

Encyclopédie des Pièces écrites en français Par des auteurs noirs

AN ORIGINAL FROM THREE CONTINENTS PRESS

my work to be quite similar to the editor's, and no less important. Her response was, "Really!?" But I stand by it. The aim of the designer is to focus and to clarify the writer's message. I sensed something at one point, and further thought has confirmed my original feeling: I love the relationships between words and pictures, I love the possibilities of those relationships. I haven't yet come close to working to my own satisfaction with them. But some—not all, but some—of the covers that 3CP commissioned gave me opportunities to work on those relationships. Fortunately, for me, the cover of *Maiba* was one of them: the first rung on a high ladder, perhaps.

I should say that I took advantage of Dr. Herdeck's acceptance of my work to be quite experimental in my own little ways. I remember that I attempted, with a cover on Oceanic literature (*Silence and Invisibility* [22]), to produce a design that would suggest Oceanic art but it also included metallic ink. On another occasion—*Who Remembers the Sea* [20] was the book—I wanted to use

the overlap of red and green to create brown. I later discovered that the printer actually employed three colors, because the challenge of creating three colors from a duotone wasn't worth the effort. *Paper Boats* [4] employed a similar (and quite successful, I feel) approach to making three colors out of two. There were several instances of this sort of experimentation and play, in which I was trying to learn new techniques while also trying to lower production costs.

I was always aiming to produce designs and illustrations that would relate to the subject, to its time and culture, in ways that would give the reader some sort of access to the contents of the book. For an illustrator-designer, there were wonderful opportunities. I spent much more time on these assignments than the remuneration justified; I felt that, at that early stage in establishing myself, the quality of the work would benefit me in the long run, if not immediately. Many of the covers included hand lettering, which I saw as another opportunity to relate the book to time, place, and culture. There were some, like four books by Naguib Mahfouz, that

DELE CHILD

RONALD DATHORNE

DELE'S CHILD

3CP RONALD DATHORNE

SILENCE & INVISIBILITY

F

A STUDY OF THE LITERATURES OF THE PACIFIC · AUSTRALIA & NEW ZEALAND
TCP ====> by NORMAN SIMMS

22

POEMS OF
TIJAN M. SALLAH

KORA LAND

An original from
Three Continents Press

23

I was able to design as something of a series. *Fountain and Tomb* was my favorite of that group [5,6].

Occasionally, but rarely, Herdeck would want to have a particular picture on the cover of the book. One of those was *Arabic and Persian Poems in English*, where the cover illustration wasn't mine; another was the "critical biography" of Joseph Conrad, where the illustration was mine, but simply drawn from a photograph he provided me.

Speaking of color experimentation, I've noticed that some of the covers you designed, especially the Mahfouz series, have been published in multiple, different color combinations. Were you the one who chose the colors, or was that done on the production end after you passed off the art?

It seems to me that I often chose the colors, and Dr. Herdeck approved them. Occasionally we would fan through a Pantone book together. After the first printing, however, I never participated in color selection, nor in the decisions to change the colors.

YUSUF IDRIS
THE CHEAPEST NIGHTS

A THREE CONTINENTS BOOK

THE SINNERS

BY YUSUF IDRIS
TRANSLATED BY KRISTIN PETERSON-ISHAQ

Did you read the novels before doing the design? What were your goals as a designer? Where you trying to channel the contents of the books, or more simply make an object people would want to pick up and read? The books come from very diverse locations, across the entire African continent, the Caribbean, the Arab world, Asia—did you feel responsible to any sort of historical sensitivity and "appropriate" representation?

Sometimes—but less than half—I was able to read the book before beginning my work. And I have to say that, as often as not, the texts were disappointing. I've done a little bit of translation, and I know that it's a risky undertaking. Most of Herdeck's translators were colleagues at Georgetown University, and some of them—this is my biased opinion—were alarmingly insensitive to language. I say this without knowing the languages being translated, yet being able to read how clumsy the English versions often were.

And I had lapses of my own. On one occasion, when I was buying popcorn at a movie theatre, I saw the concessionnaire writing

26 26a

a letter, and I was enchanted by the writing: a line, with letters hanging from it as if from a clothesline. I incorporated that concept into my next 3CP cover, only to learn later that I was incorporating Urdu into an Arabic subject. I don't believe I made many mistakes of that sort. I was occasionally frustrated by Don's willingness to ask the author's or the translator's approval of my covers. It's still galling, but it simply goes with the territory. The problem is that authors and translators seldom know much about visual presentation. Great publishers maintain a firewall between authors and artists; 3CP was a more intimate setting.

I've always been interested in art history. I actually began graduate school in that field, and I still write on exhibitions and artists for *The Washington Print Club Quarterly*. 3CP allowed me to use and to expand some of that background. And sometimes I was lucky: an early assignment from 3CP was *Tales from Cameroon* [26], and it happened to coincide with a marvelous exhibition at the Smithsonian African Art Museum. A similar moment of good

Ferdinand Oyono's third novel, written from the viewpoint of Aki Barnabas, a young Cameroonian who seeks to become "somebody" by using the rules of the colonial system to his best advantage, is the ironic study of a young man's path of deception and self-deception. Unlike Oyono's two earlier novels (Houseboy and The Old Man and the Medal), which depict their protagonists in struggles to assert their humanity, in this work we see Barnabas engaged in efforts to suppress his own human feelings in a futile quest for position and prestige.

Set in the Bula country of South Central Cameroon near Ebolowa, where Oyono grew up and attended school, we see here the often ironic consequences of Barnabas' self-loathing, which lead him to seek an embrace with "the Mother Country," France. In his attempt to escape his Africanness, which is the real point of his desire to travel to France, we are witness to the actions of a man whose self-serving mentality render him prey to his own delusions.

ROAD to EUROPE
FERDINAND OYONO

ISBN 0-89410-590-6 (cloth): -591-4 (paper)

THREE CONTINENTS PRESS

fortune occurred with *Silence and Invisibility*, which overlapped with an exhibition of Oceanic art at the Sackler Gallery. I seldom copied images from exhibitions or books, but they were useful for visual motifs or for creating a "look" that could suggest a time and place.

How do/did you negotiate between your work as a fine art printmaker and a designer?

When I came to D.C. and began to look for work, I quickly realized that there were four options: teaching, advertising art, editorial art, and so-called fine art. I had taught for too many years, and I knew how it sapped my time and creativity. I also felt that I didn't have the financial resources to sustain me while I found a footing in printmaking or painting. I was very poor, and design and illustration offered the best opportunities for survival. I wasn't interested in advertising, and Washington, fortunately, was a place where publishing was thriving. Half of the professional organizations in the country have their headquarters here, and most of them publish

newsletters and magazines. I stress that my goal, at that time, was survival. I had two sons to support. As a designer and illustrator, my aim was always—this might sound funny—to produce images that were framable as fine art. That aim, of course, was seldom realized, but it was valid.

Today I have a wide acquaintance among D.C artists. The only artists I've known who haven't had to have a day job are those who are married to doctors, lawyers, or other high earners. Wanda Gag, who in the second half of her life was a phenomenally successful printmaker and illustrator, spent a decade as a fashion illustrator, and never wanted to draw another figure again after she was able to break away from that world. The day job is a given. Even now, I teach drawing and printmaking, though only occasionally. My art isn't avant-garde, and I don't anticipate great success from it. Still, I love making it. When I look back on my design and illustration work, I find reassurance there. I had hoped to have a career designing and illustrating children's books, but never found a way to break into that market. The nearest I came to that was at the Smithsonian Institution, where I designed and illustrated elementary and middle school science curriculum materials. For a day job, it was very satisfying work. As an artist and designer, I have certain interests that are particular to me. One of them is calligraphy, or more specifically hand lettering. Another is the unusual format, or combinations of formats—ovals overlapping rectangles and that sort of thing, the expressiveness of the human figure. As I've said, I'm fascinated by the relationships between written and visual elements. My association with Three Continents Press permitted me to put those interests into practice in very gratifying ways. ⓢ

BERNARD
DADIÉ

THE
CITY
WHERE NO ONE
DIES

TRANSLATED BY JANIS A. MAYES
AN ORIGINAL FROM 3CP THREE CONTINENTS PRESS

This is an incomplete list of forty-six titles, printings, and editions of Three Continents Press books with covers designed and illustrated by Max Karl Winkler. In addition, some books include internal illustrations. The number in brackets following the entry denotes which illustration it is within this article:

Evelyne Accad, *L'excisée* (Washington, D.C.: Three Continents Press, 1989). [9]

Tawfiq al-Hakim, *Fate of a Cockroach and Other Plays* (Washington, D.C.: Three Continents Press, 1980).

Tawfiq al-Hakim, *Return of the Spirit* (Washington, D.C.: Three Continents Press, 1990). [2]

Tawfiq al-Hakim, *The Tree Climber* (Washington, D.C.: Three Continents Press, 1985).

Muhammad al-Maghut, *The Fan of Swords* (Washington, D.C.: Three Continents Press, 1991). [3]

Abu Bakr Bagader and Ava Molnar Heinrichsdorff, eds., *Assassination of Light: Modern Saudi Short Stories* (Washington, D.C.: Three Continents Press, 1990). [19]

Kathleen Balutansky, *The Novels of Alex La Guma* (Washington, D.C.: Three Continents Press, 1990).

Samad Behrangi, *The Little Black Fish and Other Modern Persian Stories* (Washington, D.C.: Three Continents Press, 1987/second edition).

Driss Chraibi, *Birth of Dawn* (Washington, D.C.: Three Continents Press, 1990). [10]

Driss Chraibi, *Flutes of Death* (Washington, D.C.: Three Continents Press, 1985).

Driss Chraibi, *The Simple Past* (Washington, D.C.: Three Continents Press, 1990).

Bernard Dadié, *The City Where No One Dies* (Washington, D.C.: Three Continents Press, 1986). [28]

Ronald Dathorne, *Dele's Child* (Washington, D.C.: Three Continents Press, 1986). [21]

Mohammed Dib, *Who Remembers the Sea* (Washington, D.C.: Three Continents Press, 1985). [20]

Paul Hazoumé, *Douguicimi* (Washington, D.C.: Three Continents Press, 1990).

Yusuf Idris, *The Cheapest Nights* (Washington, D.C.: Three Continents Press, 1989). [24]

Yusuf Idris, *The Sinners* (Washington, D.C.: Three Continents Press, 1984). [25]

Yusuf Idris, *The Sinners* (Colorado Springs, CO: Three Continents Press, 1995/second printing).

Jabra I. Jabra, *Hunters in a Narrow Street* (Washington, D.C.: Three Continents Press, 1985).

Jabra I. Jabra, *The Ship* (Washington, D.C.: Three Continents Press, 1985). [16]

Jabra I. Jabra, *The Ship* (Washington, D.C.: Three Continents Press, 1985/paperback edition with variant cover).

Denys Johnson-Davies, ed., *Egyptian Short Stories* (Colorado Springs, CO: Three Continents Press, 1995/second printing). [18]

Ghassan Kanafani, *Men in the Sun* (Washington, D.C.: Three Continents Press, 1991). [15]

Violet Dias Lannoy, *Pears from the Willow Tree* (Washington, D.C.: Three Continents Press, 1989).

Naguib Mahfouz, *Children of Gebelaawi* (Washington, D.C.: Three Continents Press, 1988/first printing).

Naguib Mahfouz, *Children of Gebelaawi* (Colorado Springs, CO: Three Continents Press, 1996/seventh printing).

Naguib Mahfouz, *Fountain and Tomb* (Washington, D.C.: Three Continents Press, 1990/third printing). [6]

Naguib Mahfouz, *Fountain and Tomb* (Boulder, CO: Lynne Riener Publishing, 1997/fifth printing). [5]

Naguib Mahfouz, *Midaq Alley* (Washington, D.C.: Three Continents Press, 1989, second edition/first printing). Cover design by Max Winkler.

Naguib Mahfouz, *Midaq Alley* (Washington, D.C.: Three Continents Press, 1990/second edition, fourth printing).

Naguib Mahfouz, *Miramar* (Washington, D.C.: Three Continents Press, 1994/second printing).

Naguib Mahfouz, *Miramar* (Washington, D.C.: Three Continents Press, 1994/third printing). [7]

Naguib Mahfouz, *Miramar* (Colorado Springs, CO: Three Continents Press, 1996/fourth printing). [8]

Ferdinand Oyono, *Road to Europe* (Washington, D.C.: Three Continents Press, 1989). [27]

René Philombe, *Tales from Cameroon* (Washington, D.C.: Three Continents Press, 1984). [26] [26a]

Tijan M. Sallah, *Kora Land* (Washington, D.C.: Three Continents Press, 1989). [23]

Sam Selvon, *The Housing Lark* (Washington, D.C.: Three Continents Press, 1990).

Sam Selvon, *Moses Migrating* (Washington, D.C.: Three Continents Press, 1992).

Norman Simms, *Silence and Invisibility: A Study of the Literatures of the Pacific, Australia, and New Zealand* (Washington, D.C.: Three Continents Press, 1986). [22]

Russell Soaba, *Maiba* (Washington, D.C.: Three Continents Press, 1985). [1]

Nabie Yayah Swaray, *Worl' Do for Fraid* (Washington, D.C.: Three Continents Press, 1990). [12]

Hilary Tham, *Paper Boats* (Washington, D.C.: Three Continents Press, 1987). [4]

Harold A. Waters, *Théâtre Noir: Encyclopédie des pièces écrites en français par des auteurs noirs* (Washington, D.C.: Three Continents Press, 1988). [17]

Isaac Yetiv, *1001 Proverbs from Tunisia* (Washington, D.C.: Three Continents Press, 1987). [14]

Carol Yoder, *White Shadows: A Dialectical View of the French African Novel* (Washington, D.C.: Three Continents Press, 1991).

Joseph Zobel, *Black Shack Alley* (Washington, D.C.: Three Continents Press, 1988/second edition). [13]

DYNAMIC COLLECTIVITY

PRACTICING ARTISTIC DIRECT ACTION AND ECONOMIC SUSTAINABILITY WITH THE PUNCHCLOCK PRINTING COLLECTIVE

BY RYAN HAYES

I'm sitting with Rocky Dobey in his basement studio. The long-time street artist—who's been active in Toronto since the late 1970s—lists collective after collective he's worked with over the years: No Right Turn, Anti-Racist Action, Purple Institute, Symptom Hall, Blackbird, countless anarchist gatherings and book fairs, and most recently, Punchclock. Speaking from decades of experience, Rocky observes, "The interesting thing about collectives is they don't last forever."

Nor are they static. The Punchclock Printing Collective is a perfect illustration of the dynamic nature of collectivity. I encountered Punchclock's screenprinted posters as a young activist in the mid-2000s, along with their parties that combined art and music to raise money for indigenous sovereignty movements. A few years later, when I built up enough confidence to see myself as an artist, Punchclock had faded from sight.

By connecting with former members of the group, I learned that Punchclock still exists—as a collective space with shared rent—but that its core membership transitioned from self-taught activist artists to recent art school graduates. The current Punchclock members don't have relationships with social movements but maintain close ties with spheres of cultural production including visual artists, small press fairs, and indie musicians.

This article explores how Punchclock formed and evolved over time from the perspective of four key members: Shannon Muegge, Stefan Pilipa, Rocky Dobey, and Simone Schmidt. When this group of outsider artists came together, new collective relationships allowed them to transcend their singular capacities and make important contributions to social struggles.

OCAP medallion, Stefan Pilipa, 2010.

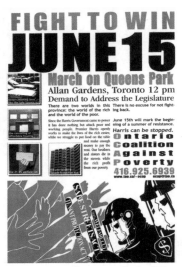

Fight to Win, offset poster, Stefan Pilipa, 2000.

Punchclock's eventual depoliticization is a good example of the challenges with sustaining prefigurative collectives. Punchclock had to contend with a hostile political climate, an atmosphere of aggressive gentrification, and an economic reality where ethical sourcing is incredibly difficult with limited funds. Along with these external pressures, Punchclock experienced a wave of personal transitions and health issues, which were intensified by the lack of a proactive process to renew and diversify its membership, loose operating rules, and devaluing of cultural work by their social movement allies.

Because these challenges still exist, and because Punchclock and its membership were continually transformed by their engagement with these realities, their example is worth examining in greater detail.

GNARL AND BUCKLE: CONFRONTING NEOLIBERALISM

Shannon Muegge and Stefan Pilipa started Punchclock in 2003 as a space to screenprint for activist groups and non-profits. Shannon and Stefan were friends who met through the Ontario Coalition Against Poverty (OCAP), best known for organizing militant demon-

Prison Justice Day, relief print, Rocky Dobey, 2003.

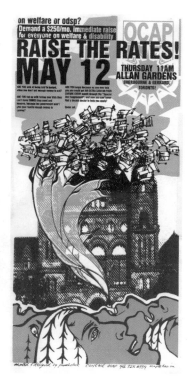

Raise the Rates, screenprint, Stefan Pilipa, 2005.

strations and its model of direct action casework.

On June 15, 2000, OCAP organized a march to the provincial parliament that became known as the "Queen's Park Riot." In response to vicious neoliberal attacks on poor and working people, OCAP called for a shift from the passive "mass therapy" style of routinized pro-test towards "organizing with the intention to actually win."[2]

Despite mass arrests, organizers saw June 15 as a watershed moment. They asserted that "The call to 'fight to win' was taken up by others, [which contributed to] building real resistance in this province and beyond." As OCAP member

OCAP flag, designed by Stefan Pilipa, 2005

A.J. Withers reflected, "While there is no doubt that repression has increased exponentially since June 15, OCAP has met it with ingenuity, creativity, and resilience."

Along with 250 others, Shannon and Stefan faced politically motivated charges for participating in the Queen's Park Riot. The noxious experiences of being arrested, facing criminal charges, and living with restrictive bail conditions were, in some ways, a perfect cauldron for the development of Punchclock. It is an example of the ingenuity, creativity, and resilience that came out of these struggles.

BALANCING ACTS: ECONOMIC SUSTAINABILITY AND ARTISTIC DIRECT ACTION

Attempting to address a mixture of competing needs and desires with a new kind of organization, Punchclock declared a mandate of economic sustainability and artistic direct action.

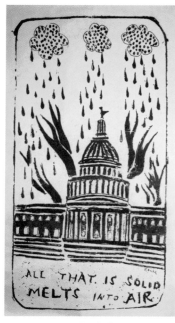

All That Is Solid..., Rocky Dobey, screen-printed by Shannon Muegge, 2005.

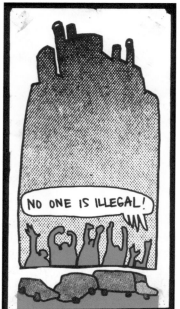

No One Is Illegal, screenprint, Shannon Muegge, 2004.

The plan was to pay rent and wages by offering original designs and printing to organizations with funding and, in turn, for this income to underwrite work for grassroots groups they wanted to support.

Shannon describes the beginnings of Punchclock as a natural fit between the activist art she and Stefan were making with OCAP and her paid work printing T-shirts in a basement. Stefan also had experience with screenprinting as an extension of designing political posters. He adds, "The politics of collectivism just came with us. It was a project for us to try to live, to do something cool and meaningful and long-lasting."

In the spring of 2003, Shannon and Stefan rented a studio in a downtown Toronto warehouse. The unit was 400 square feet, with no windows, ventilation, or a proper drain. "Looking back on it, it's

cringe-worthy, some of the stuff we were doing, but I think it's part of the process. You have to make those mistakes. We'd flood the auto detailer that was below us. It was total anarchy, the bad kind of anarchy!" recalls Stefan.

Punchclock operated out of this space for only a few months until moving into a one-thousand-square-foot unit downstairs in the same building. Most of the equipment was bought second-hand. "One shop would be going out of business and you'd be able to buy up all of their ink," says Shannon. Stefan was able to piece together a functioning exposure unit for burning screens from used and broken equipment.

The following year Punchclock started bringing new people on board to share the equipment and help pay the rent. "That's kind of when the idea of it being a collective came about," says Shannon.

At one point we had way too many people. Two bands were using it as practice space, but it was not big enough to be that multi-purpose. At that point we decided to boil it down to five or six printers, and that was the steady balance we struck: Will Munro, who has passed away now, Michael Comeau, an amazing artist, John Caffery, from the band Kids on TV, Simone Schmidt, Stefan, and I.

Shannon describes Punchclock as a "mythological beast" that changed form many times. This resonates with collective member Rocky Dobey's account

of Punchclock as a space with multiple nodes of activity:

It was a great collective, you could tell right away. There was something happening there every weekend. There were a lot of parties. I remember one time it was -30°C and they met at a party to go out and do street art by the railroad tracks. Shannon did a lot of these railroad track treks. There was always people working, printing, bands practicing, it was just a great place to go. Every time I went in, there was always new projects. People used it as collective space.

Punchclock meant different things to people based on their particular interests and points of contact. Simone Schmidt, an activist and artist who met Shannon and Stefan through

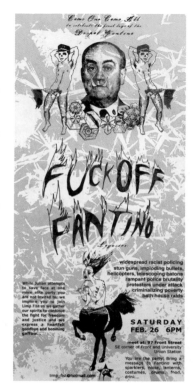

Fuck Off Fantino, screenprint, Shannon Muegge & Hunter Cubitt-Cooke, 2005; *Theft*, installation, Shannon Muegge, 2007.

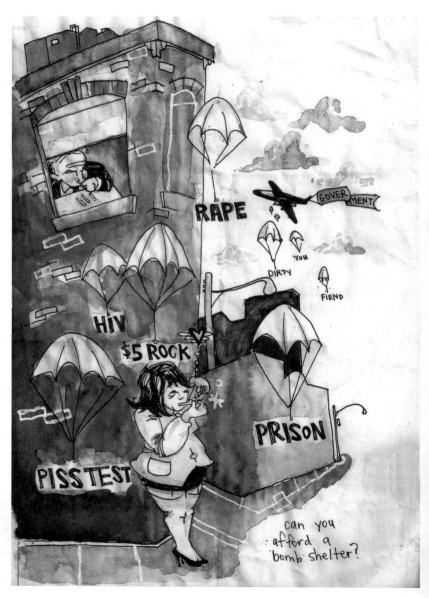

OCAP, says Punchclock's party atmosphere was partly a response to the chronic stress of political organizing. "Half of the people were in OCAP and doing really serious anti-poverty organizing, so they were like, 'You know what? We're here, we're queer, let's party.'"

Stefan describes loftier goals, like creating a space to develop skills for working together cooperatively, as a way to fight the alienation of a deeply competitive society. When I ask Stefan about how Punchclock defined artistic direct action, he says:

Artistic direct action was a combination of OCAP sloganeering and our artistic sensibilities. Some of the actions that Shannon did were literally artistic direct actions. What Rocky does on the streets with his metal plaques, it's pretty action-packed. He's a machine and a monster when he works. And also just thinking of all the examples of OCAP paraphernalia that came out of the studio, things like pennants, flags, and placards. I wanted the bodies and thoughts of the people at the demonstrations to be magnified by the materials we made. I wanted the protest presence to be overwhelming for the state.

So I wanted to depict an aura of organization and a unified message. I would print hundreds of oversized flags in bright colours so that there was a sense of unity. Because in North America, we are a heterogeneous culture and when we go to demonstrations we are not skilled at acting as a unified body.

Stefan eventually moved on because there was not enough paid work at Punchclock to support both him and Shannon fulltime. His role as a de facto studio technician was a significant part of his evolution towards metalworking and the creation of a new collective, Punchclock Metal, in 2006. In 2007, Shannon also decided that she needed to change careers; she and Stefan gave the business and managing position of the studio to Simone Schmidt.

God Loves Abortion, screenprinted T-shirt, Simone Schmidt, 2007. Opposite page: *Love Who You Will*, screenprint, Shannon Muegge, 2005; *Toronto Resist G8/G20*, digital print, Rocky Dobey, 2010.

LOVE
WHO
YOU
WILL

JUNE 2010 TORONTO RESIST G8/20
G20.TORONTOMOBILIZE.ORG

JOIN US!
JUNE 21-27
DAYS OF ACTION

A PEOPLES CONVERGENCE FOR INDIGENOUS SOVEREIGNTY
AND SELF DETERMINATION, FOR MIGRANT JUSTICE AND AN
END TO WAR AND OCCUPATION, FOR ENVIRONMENTAL AND
INCOME EQUITY AND COMMUNITY CONTROL OVER RESOURCES

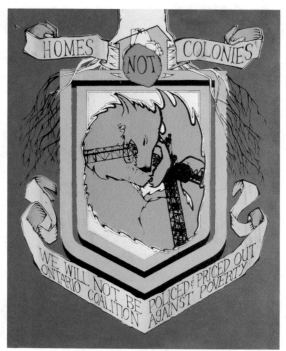

Homes Not Colonies, screenprint, Stefan Pilipa, 2007.

HOMES NOT COLONIES: CREATIVE RESISTANCE TO GENTRIFICATION AND COLONIALISM

Simone dropped out of university at nineteen to do housing organizing with OCAP. Because Simone designed fliers for OCAP, Stefan and Shannon invited her to work out of Punchclock. While organizing, Simone became very familiar with the struggle for housing in the Parkdale neighborhood where Punchclock was located. She says, "The change that needed to happen in the neighbourhood wasn't the change that came."

A dotcom entrepreneur opened the swank, newly renovated Drake Hotel in 2004 with

Economic Disruption for Land & Survival, screenprint, Stefan
Pilipa, 2008.

a manifesto that it would become
a community centre for artists,
while in reality it quickly became
a beacon for gentrification. In re-
taliation, Punchclock organized
a street party called Noise Attack
on the night of a major opening.
Their stunt attracted attention
from local residents, wealthy pa-
trons of the Drake, and an array
of police paddy wagons:

Chris Eby, who would DJ at our
parties, had this big rig of power-
ful speakers on a bike trailer. We
had all different people doing stuff.
There was confetti that on one
side said "crack" and the other side
said "illegal" and then another one
that said "cocaine" and "legal." We
started from Punchclock and made
the short walk to the Drake. The
police had already arrived once we

Vazaleen Memorial, screenprint, Michael Comeau, 2010.

got there. And we actually had only planned to have a street party. So we were doing a great party and then the speakers got confiscated. But it was enough to bring three paddy wagons to the vicinity.

The warehouse in which Punchclock was located was effectively evicted in 2008 due to a rise in rents. In an act of supreme irony—or conquest—the condos built on the site of their demolished building were marketed as Art Condos. Simone oversaw Punchclock's move to a new space, where Punchclock Metal was already based.

Along with sparking creative resistance to gentrification, Simone organized events to draw attention to indigenous sovereignty movements. As a gesture of support for a Mohawk activist facing charges, Punchclock issued a call for art and planned two events under the banner of Shawn Brant Is No Criminal:

With parties, I think much like the idea of taking money from projects that were lucrative and funding print work for activist organizations, we decided to take money from indie rockers that we knew were going to spend $5 on a Friday night. We knew Shawn Brant because of OCAP. Members of the Tyendinaga Mohawk Territory were involved in a struggle against mining on their land, and at the time there was not that much talk about it. Same with the Boycott, Divestment, and Sanctions movement against Israel. At the very least we decided to try to get money out of indie rockers.

Tyendinaga Mohawk Tobacco, logo, Shannon Muegge and Stefan Pilipa, 2003.

Shawn Brant Is No Criminal, screenprint, Simone Schmidt, 2008.

At the very most, involve them in some consciousness-raising.

Support for Shawn Brant and Tyendinaga was part of a symbiotic relationship for Punchclock. From 2003 to 2005 Punchclock produced labels and packaging for Tyendinaga tobacco, building upon friendships and political bonds that were forged through OCAP. Fundraising events also included an element of reciprocity. Simone would

barter free printing in exchange for performances, knowing that musicians struggled to make a living in the economy.

Likewise, economic challenges were an ongoing concern for Punchclock. When Simone shifted to printing full-time, she felt pressure to generate business, while trying to source fair-trade shirts and absorb the cost of moving from toxic plastisol to healthier water-based inks. Printing-for-pay intensified

Rocks vs. Tanks; Birds vs. Airplanes, screenprint diptych, Shannon Muegge, 2003.

environmental concerns that were especially acute when making shirts for one-day-only events like charity runs and activist gatherings.

Amidst these economic and environmental tensions, Simone was getting physically sick from printing, her partner was fighting cancer, and Punchclock faced a stark turnover in membership: "Shannon was gone and hadn't wanted to print anymore because of personal factors in her life. Stefan was into the metalshop, Michael Comeau developed health problems and wasn't able to print, and Will Munro died."

Efforts to wrangle together a new generation of printers were impeded by a lack of interest in collective process and house-keeping. Simone describes having to put up signs about cleaning up after

was. tanks

yourself as frustrating and "kind of ridiculous."

A lot of the new ethic in DIY culture seemed to only have to do with people resisting art school. People wanted to assert their separate practices and start climbing the rungs to art stardom. They'd put art in the smaller storefront galleries that, during those first years of gentrification, took the places of cheap restaurants, pawn shops and corner stores in Parkdale. They'd show at the Drake with no notion of all its real and symbolic implications for poor people in the neighbourhood. They didn't see their own freedom as artists as bound with the rights and struggles of other poor people. I saw a lot of this attitude—people didn't want to be involved in any democratic process, had no interest in meeting, and no desire to try to form something new together. I remember we had a meeting at

a airplanes

Dark Age Ahead, painted etching plate, Rocky Dobey, photo by David Owen, 2009

Punchclock, we brought everyone who was interested in renting in, and I was like, "Okay, does anyone want to keep a speakers' list?" And I realized that was such a weird idea to some people because they had never operated in an environment where that had been used. Over the course of the meeting, the men talked. And the women were like . . . [silence]. And the conditioned order of mainstream culture prevailed. But I didn't know how, as one person, to break that down.

In late 2009, Simone shifted her focus to writing and performing music full-time. "I endured an amount of hardship in my personal life that required a more nuanced outlet." Working with movements was fraught with a red and black understanding of how things are, whereas she "found it easier in song and language and poetry to have a few different readings."

COLLECTIVE ANALYSIS: EXPERIMENTS WITH PREFIGURATIVE CULTURE

In 2013, after a chat outside of Punchclock Metal, Stefan brought me to meet

Vazaleen Memorial, screenprint, Michael Comeau, 2013.

Jacob Horwood, who took over the administrator role at Punchclock Printing after Simone left. When I met Jacob he was printing a poster designed by Michael Comeau for a party in honor of the Will Munro Fund for Queers Living with Cancer. Punchclock was preparing to move into a more spacious unit, which would allow it to share space with Jesjit Gill's risography-based Colour Code Printing, upgrade its equipment, and bring a few new renters on board.[3]

Although Punchclock fell off my radar with its disconnection from movement circles, it's easy to see how it may have never left for people rooted in different scenes. My research started from a desire to be a part of the Punchclock that I missed, and quite possibly, mis-imagined. By hearing people's firsthand experiences, I've realized that the complexities, tensions, limitations, and failures that Punchclock encountered are just as instructive as their successes. This is particularly true when considering Punchclock's engagements with accessibility, collective process, and points of contention with movements.

* * *

Punchclock supported crucial work that many people were not touching at the time: direct action anti-poverty organizing, Palestine solidarity activists in their efforts to launch the Boycott Divestment Sanctions movement, non-status migrant justice campaigns, and indigenous land defense struggles that were being criminalized by the state. Punchclock directly contributed to these movements working to dismantle destructive systems of capitalism and colonialism through their art-making and fundraising efforts.

That said, the absence of a more proactive policy to ensure access to the collective by people of color and other equity-seeking groups hindered the transformative potential of their work and limited their sustainability as a political project. Without creating new opportunities for access and education, Punchclock primarily made art for struggles rather than with them—they weren't able to prioritize supporting others to find their artistic voices. As a result, when faced with a stark turnover in membership, Punchclock was

limited to the existing pool of printmakers in Toronto, predominantly art school graduates—who in some ways are more diverse—but who did not necessarily share the same commitments to collective process and challenging power.

One way to view Punchclock's structure is as a missed opportunity, because the informal nature of the organization led to an inability to fully ingrain the political dimension of Punchclock's mandate. Rather than rigid politics, Punchclock organized around a series of tacit agreements rooted in flexibility and compromise. And yet, by adopting a pragmatic approach, the organization evolved and survived rather than collapsing from the weight of its political ambitions and social contradictions. Punchclock overcame early difficulties by embracing hybridity and clearly gained from the cross-pollination that came with the collective practices of resource sharing and collaboration. Although Punchclock's activist mandate has gone into hibernation, if there were enough interest in seeing this activity emerge again, all the

Punchclock Showcase III, screenprint, Michael Comeau, 2009.

instruments are still in place.

To resist the seductive grip of nostalgia, it is worth remembering that even though Punchclock oriented itself towards the activist community, there were recurrent tensions in this relationship. These points of friction reveal how cultural work and social movements often exist in uneasy relationships. When speaking about her artistic approach, Shannon highlights this:

In terms of my style, it being more personal, more narrative, influenced by an aesthetic interest in beauty that is suspended above activist branding—I found it really difficult to do graphic design for activists, which is sort of what we were pitching ourselves to be. I don't know if I really succeeded in that. In Punchclock there was always this bit of tension where I'd make things that were a little too weird, or not so simple, not like a red star on a black flag kind of thing. So yeah, I love illustration, and I love more complicated stories and aesthetics than activists usually go for.

Rocky mentions that when he produces posters, he also has to deal with narrow ideas about what activist art should look like:

Often people don't like it. They say "Can't you have a fist?" Nobody liked this poster when I handed that one in [gesturing to the 2001 FTAA poster].

And now it's considered a classic. What did they say?

Can you make the text bigger?

Can you put some flags in there?

Yeah, exactly. It's okay, they can say what they want. But this is what I do and I do it for free. So imagine if you're always doing it for money. You're going to be slowly compromised—you're going to move your work towards that.

Having an established personal practice creates space for setting boundaries when working with movements. You can say: "Look, if you're asking me, this is the kind of work that I do, so keep that in mind." However, the reality is that some people

Carnival Against Capitalism, offset poster, Rocky Dobey, 2001.

No More Bantustans, screenprint, Simone Schmidt, 2007.

Punchclock Showcase I, screenprint, Michael Comeau, 2007.

don't trust images—and maybe for good reason. For people who want to micromanage everything down to a single correct reading, many images prove too unwieldy.

Rocky's work is a prime example of this. His intricate compositions, which begin as etchings on copper plates, have a very personal feel and yet leave plenty of room for interpretation. His style is transfixing partly because it is so different than everything else that you see. Like the 2001 FTAA poster, many of Rocky's images feature buildings that are in states of upheaval and destruction. They're apocalyptic visuals

that invoke, sometimes explicitly, Marx's declaration that "All that is solid melts into air."

When I ask him about the buildings' significance, he asks me what I think. Then, pointing to copper plates on his worktable, he says, "That's a log tower, to me that's colonial. Everything is a building, kind of, that I do. I don't know. Power—they look like prisons, they look like office towers." Rocky explains that he worked in highrises as a construction worker for many years. He used to dream of buildings. They are a potent symbol, able

Boycott Chapters/Indigo, screenprint, Stefan Pilipa, 2007.

Boycotting Israeli Apartheid, screenprint, Simone Schmidt, 2006.

to express multiple dimensions of his identity, experiences, and anti-authoritarian politics.

If Rocky offers a sense of apocalyptic possibility, that amidst a suspension of social norms new realities can emerge, Stefan takes the same theme of large-scale disruptive action and grounds each image in specific struggles. Stefan is credited by his fellow artists for successfully balancing the need to produce images that communicate the urgency and militancy that

activists want, while still offering interesting and imaginative visuals. When Stefan talks about his affinity for the aesthetics of medieval heraldry and banners, which are strong features in the hand-drawn Homes Not Colonies, Economic Disruption, and Boycott posters, he relates this to a goal of connecting with people on a visceral level.

Empathic connections are an important but often overlooked aspect of social justice organizing. Simone gravitated towards

music because there was a lack of engagement with these issues in movements. Reflecting on her art practice, and a departure from a red and black understanding of politics, she says:

I think my only really successful poster was a bouquet of all the provincial flowers, and it just said "These flowers were picked from stolen land." And then it said "Free Shawn Brant." It was a six-colour Victorian print of flowers.

So, kind of disarming, because at first you only see the flowers and not the meaning behind it.

Right, it's something my mom has up at her cottage, which is obviously not effective because she has a cottage in Muskoka, but the reality is that every time she looks at it, she has to contend with the idea. I think sometimes art is just a reminder. It's not a movement.

Producing art that intervenes in the realm of ideas is part of the long-term organizing needed to create cultural shifts within mainstream conceptions of gender, race, sexuality, disability,

migration, capitalism, and colonialism. If you start to imagine how people might connect with an image on a personal level, and how such an image can embody your liberatory ideals, you are in the idea space that Favianna Rodriguez talks about in her article "Change Culture, and the World."[4] Rodriguez points out that too often this crucial work is neglected at the expense of supporting immediate actions. Shannon suggests that critical engagement with aesthetics could allow activists to connect with people outside the same typical echo chamber and beyond the limited framework of reactionary politics.

Culture is not just a tool for movements to wield, it is its own terrain for struggle. As Simone puts it, "Aesthetic choices are also material choices." They're deeply political. If we mimic the dominant aesthetics of corporate culture, we should consider why we're doing this. Is it because we're seeking legitimacy? To project the idea that we're not just some rag-tag group of activists? And if so, why do we associate legitimacy with

THESE FLOWERS WERE PICKED FROM NATIVE LAND
FREE SHAWN BRANT

Free Shawn Brandt, screenprint, Simone Schmidt, 2008.

this slick advertising aesthetic? What does it mean when DIY or movement aesthetics get co-opted by corporate culture? In our social justice campaigns, we should consider how the materials we produce relate to these struggles. What does it mean if we use sweatshop T-shirts, paper from clearcut forests on unceded native land, harmful chemicals in our studios, or produce things that are effectively disposable the day after our actions? Mitigating this reality is a necessary part of our political work as we continue organizing to change the underlying conditions that produce them.

* * *

The name "Punchclock" is a reference to the experience of industrial workers under capitalism: work as a prison house of measured time, increasingly standardized and controlled. The way that our bodies are disciplined as laborers—both paid and unpaid—is yet another step in the enclosure of social life. Today workers in "creative" industries are an archetype of the new norm: a lean, self-disciplining, freelance economy where we're always working, and expected to do more with less.

Collectives and cooperatives attempt to confront this individuation by reclaiming common spaces—prying our labor away from systems of domination and redirecting our resources towards more caring, fulfilling, and collective ends. Collectives can be self-serving and exist for the benefit of a select few, yet they also have the potential to act in collaboration with struggles against injustices on a scale that transcends our individual capacities. As experiments in prefiguring new worlds—even if swift and changeable—they suggest possible ways forward for nonhierarchical organizing towards transformative social justice. ⑤

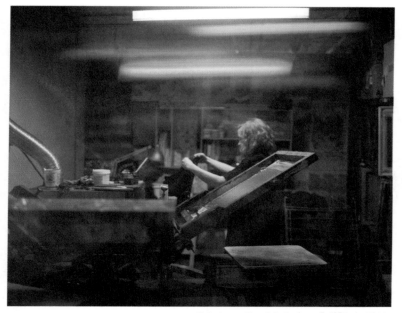

Printing at Punchclock, photo Jeff Bierk, 2014.

1. Alan Moore, "General Introduction to Collectivity in Modern Art" in *The Journal of Aesthetics and Protest* (2002): http://joaap.org/new3/moore.html

2. Stefan Pilipa, "The 'Queen's Park Riot' and the Politics of Provocation: Another Look at June 15th" in *June 13½* (2002). *June 13½* is a small book produced by the "Queen's Park Riot" Defendants. The number 13½ refers to the prison justice slogan: one judge, twelve jurors, and half a fuckin' chance.

3. I eventually became one of the new renters at Punchclock and continue to print there today.

4. Favianna Rodriguez, "Change Culture, and the World" (2013): http://culturestrike.net/change-the-culture-change-the-world

5. *20 Years of Organizing the Fight Back,* title page image (p. 142), designed by Stefan Pilipa, 2010.

6. Many of the works included here were intentionally left unsigned by their creators. Identifying information has been added after the fact for analytical purposes.

CONTRIBUTORS

Lincoln Cushing is an archivist and author who documents, catalogs, and disseminates oppositional political culture of the late 20th century. His books include *Revolucion! Cuban Poster Art*, *Agitate! Educate! Organize!: American Labor Posters*, and *All of Us or None: Social Justice Posters of the San Francisco Bay Area*. He was an original organizer of the Bay Area Peace Navy. For more, see www. docspopuli.org.

Rochelle Davis is an associate professor of anthropology at the Center for Contemporary Arab Studies and author of *Palestinian Village Histories: Geographies of the Displaced*.

Jared Davidson, a screenprinter and graphic designer turned archivist, is the author of *Sewing Freedom: Philip Josephs, Transnationalism & Early New Zealand Anarchism* and other works on the intersections of power, culture, and class. He lives in Wellington, Aotearoa New Zealand, and is a member of the Labour History Project.

Alec Dunn is an illustrator, printer, and nurse living in Pittsburgh, PA. He is a member of the Justseeds Artists' Cooperative.

Ryan Hayes is an artist, activist, and archivist based in Toronto, ON. He is a member of the Radical Design School (www.radicaldesignschool.net) and blogs at www.blog.ryanhay.es.

Josh MacPhee is one of the founders of the Interference Archive and Antumbra Design. He also organizes the Celebrate People's History Poster Series and is a member of the Justseeds Artists' Cooperative.

Michael McCanne was born and raised in Northern California. He holds a master's degree in history from Goldsmiths University

of London. His writing has been published by *The New Inquiry*, *The Baffler*, *Satellite Magazine*, *Fanzine*, and *The Brooklyn Rail*.

Emma Murphy is a Mortara Undergraduate Research Fellow at Georgetown University studying Arabic and international politics in the School of Foreign Service.

Tennessee Jane Watson is an instigator, artist, activist, and public survivor. As an award-winning documentary media producer, her practice focuses on finding creative and supportive ways to encourage transgressive thought and action. Her latest project, www.autonomousmemoryfront.org, is an interactive audio archive that challenges how the movement to end child sexual abuse has historically approached silence, and that re-imagines the politics of survivor disclosure. See some of other stuff she makes at http://vimeo.com/tennesseejane.

SIGNAL:01

A Journal of International Political Graphics
edited by Alec Dunn & Josh MacPhee

SIGNAL:02
A Journal of International Political Graphics & Culture
edited by Alec Dunn & Josh MacPhee

SIGNAL:03
A Journal of International Political Graphics & Culture
Edited by Alec Dunn & Josh MacPhee

"I can't think of any other design or visual arts publication quite like *Signal* in form and content. It is half way between a magazine and a book in appearance and tone. Its dinky size, combined with astutely pitched, matt-laminated cover designs, make it immediately intriguing and attractive."
—Rick Poynor, *Design Observer*

"Dunn and MacPhee do an impressive job of conveying not only what is new and relevant in political art, but also its history and its presence in the everyday."
—*Political Media Review*

PM Press was founded at the end of 2007 by a small collection of folks with decades of publishing, media, and organizing experience. PM Press co-conspirators have published and distributed hundreds of books, pamphlets, CDs, and DVDs. Members of PM have founded enduring book fairs, spearheaded victorious tenant organizing campaigns, and worked closely with bookstores, academic conferences, and even rock bands to deliver political and challenging ideas to all walks of life. We're old enough to know what we're doing and young enough to know what's at stake.

We seek to create radical and stimulating fiction and non-fiction books, pamphlets, T-shirts, visual and audio materials to entertain, educate, and inspire you. We aim to distribute these through every available channel with every available technology—whether that means you are seeing anarchist classics at our bookfair stalls; reading our latest vegan cookbook at the café; downloading geeky fiction e-books; or digging new music and timely videos from our website.

PM Press is always on the lookout for talented and skilled volunteers, artists, activists and writers to work with. If you have a great idea for a project or can contribute in some way, please get in touch.

PM PRESS
PO Box 23912
Oakland CA 94623
510-658-3906
www.pmpress.org